IMAGES
of America

WILMINGTON
AND THE
WHITEFACE REGION

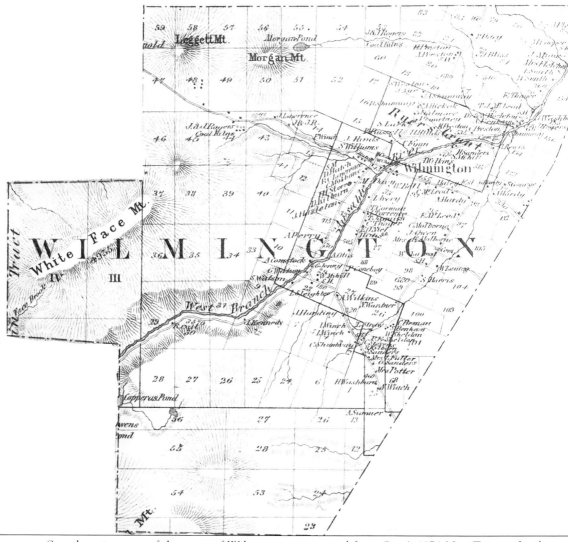

Seen here is a map of the town of Wilmington, excerpted from Gray's 1876 *New Topographical Atlas of Essex County*. Two historical land grants—the Ryers Grant at the top right and a portion of the Mallory Grant at the lower right, which extends into the adjacent town of Jay—can be discerned. Whiteface Mountain and the West Branch of the AuSable River clearly dominate the landscape. (Courtesy of the Wilmington Historical Society Library.)

ON THE COVER: Taken prior to 1890, this image shows the Wilmington wooden bridge and dam on the AuSable River's West Branch at the base of Whiteface Mountain with a former sawmill site on the right and a gristmill in the right foreground. The river provided mechanical waterpower for early industry and served as the transportation highway for local logging operations. (Courtesy of the Wilmington Historical Society.)

IMAGES
of America

WILMINGTON
AND THE
WHITEFACE REGION

Wilmington Historical Society

ARCADIA
PUBLISHING

Copyright © 2013 by Wilmington Historical Society
ISBN 978-0-7385-9924-3

Published by Arcadia Publishing
Charleston, South Carolina

Printed in the United States of America

Library of Congress Control Number: 2012954311

For all general information, please contact Arcadia Publishing:
Telephone 843-853-2070
Fax 843-853-0044
E-mail sales@arcadiapublishing.com
For customer service and orders:
Toll-Free 1-888-313-2665

Visit us on the Internet at www.arcadiapublishing.com

CONTENTS

ACKNOWLEDGMENTS

This project would not have been possible without the many contributions of photographs, stories, and time that have been generously donated. We would like to give special thanks to a few and sincerely apologize if we have missed someone who should have been included. Over 2,000 photographs were scanned and considered for publication, and we wish we could have used them all. It was difficult to select the final images; however, we were restricted to just over 200 photographs for publication. The images not used for this publication will enhance our Wilmington Historical Society collection for future use.

Special thanks to the Olympic Regional Development Authority at Whiteface, curator Michelle Tucker at the Saranac Lake Free Library, director Allison Haas of the Lake Placid Olympic Museum, Robert Reiss of Santa's Workshop Incorporated, Lamar Bliss (granddaughter of D.P. Church) and the St. Lawrence University D.P. Church Collection, author William J. "Jay" O'Hern, and Haselton Lumber Company vice president Pamela Haselton Gray for donating their time and allowing us to use their special collections. Suzanne Underwood Field's unique collection of personal photographs and stories about Wilmington's summer residents and camps added perspectives heretofore unexplored.

Thanks also to Debbie and Jeff McLean, owners of the UPS store in Lake Placid, for going above and beyond with special photograph copying requests.

A sincere thanks goes to Julie Robards, who organized images and wrote the captions for the Santa's Workshop chapter, and to Laurie Bepler for her time, travel, insight, and direction in getting this project started. Also, thanks to Virginia Crispell for editing assistance.

We extend our gratitude to Robert Peters for his endless hours spent scanning and copying over 2,000 photographs, helping with interviews, and providing technical assistance. Also, special thanks to Guy Stephenson for his family collection of photographs, research, and writing time.

Thank you to the Wilmington Historical Society Board members Nancy Cressey, Robert J. Cressey, Gilbert Dyke, Linda Joss-Dyke, Merri C. Peck, Karen Marshall Peters, and Douglas A. Wolfe for their time and effort in selecting images, researching topics, writing captions, and editing text, all of which enabled the completion of this worthwhile project.

INTRODUCTION

The town of Wilmington was founded nearly 200 years ago by hardy pioneers from New England who were searching for land and a self-sufficient way of life. Over the years, it has been transformed from an obscure agricultural/industrial town on the banks of the AuSable River to a popular four-season tourist resort.

The first residents of Wilmington arrived after the Revolutionary War, around 1800. Like most Americans at the time, many were farmers. Forests provided resources for building the first log homes and furnishings as well as for food, clothing, and items for trade. Gristmills, sawmills, and distilleries sprang up along the West Branch of the AuSable River. During the War of 1812, Wilmington supplied the militia with some of the best local whiskey. Reuben Sanford, who arrived in 1803 and constructed a home in the center of the hamlet in 1812, was the first industrialist in Wilmington. Among other pursuits, he built a potash factory to make lye for soap and other products, buying ashes from local farmers as they cleared their land. A starch factory used potatoes from local farmers in its manufacturing process. From the 1820s to the 1880s, lumbering operations in Wilmington and the surrounding area provided charcoal to supply iron mining and forge operations. The Sable Ironworks, established by Sanford, was among the first ironworks in the area. Others followed, but by the 1890s, the iron industry shifted westward, and the immediate focus turned to lumbering as a resource for the area's pulp and papermaking industry. In 1901, the Haselton Lumber Company opened to provide wood products to the local area and beyond. As Wilmington was settled, supporting community buildings were constructed, including churches, schools, post offices, and a town hall. Over the last century and a half, all of the public structures underwent numerous changes, with many of them changing physical locations.

The West Branch of the AuSable River and other local ponds and streams provided fish for sustenance of the early settlers and later became popular for tourists who wanted to be guided to the best places to hunt and fish. Many Adirondack hunting and fishing guides plied their trade in the Wilmington area. Hoteliers also supported guides to lead visitors on local mountain trails, including the routes to the peak of Whiteface Mountain. The famous "Adirondack Hermit," Noah John Rondeau, made Wilmington his last place of residence in the 1960s when he retired from his Cold River home. By the 1960s, the West Branch of the AuSable River was touted as a world-class fishing stream. Spring still brings anglers from across the country, thanks in large part to Wilmington's fly-fishing author and promoter, Fran Betters.

Surrounded by the natural beauty of the West Branch of the AuSable River and Whiteface Mountain, the area gradually gained a reputation as a scenic resort. As the 19th century drew to an end, easier access to ore in the Midwest led to the closure of the local iron forges. Emphasis began to shift from traditional industry and farming to the relatively new business of tourism. Photographers, like the famous Seneca Ray Stoddard, introduced the scenic attractiveness of the area to the rest of the world with images of Whiteface Mountain, High Falls Gorge, and Wilmington Notch. Wilmington entered the golden age of hotels, tourist cottages, and Adirondack-style camps.

Private entrepreneurs—such as Frank Everest of the Whiteface Mountain House, Edwin and Oscar Olney of the Olney Hotel, and Lewis Bliss of the Bliss House—operated their hotels, and gradually the town's reputation grew. In addition, many people from nearby cities built summer camps and spent their time here relaxing and participating in recreational activities. Wilmington, home of Whiteface Mountain, was on the map. In the early 1930s, construction of the Whiteface Mountain Veterans Memorial Highway was begun. It was dedicated in 1935 to the veterans of the First World War by Pres. Franklin Delano Roosevelt. The highway has since become one of New York State's most popular attractions.

By the 1940s, downhill skiing became a significant new winter sport in America, and the Whiteface Mountain Ski Center was inaugurated, first at Marble Mountain, then, in 1958, at the current site. With this development, tourism in Wilmington was expanded to the winter season. Ski legends, including Otto Schniebs, Walter Prager, and "Jack Rabbit" Johannsen, came to Wilmington to make trails and develop the sport of downhill skiing. With the advent of the 1980 Winter Olympics, the world watched as Whiteface Mountain Ski Center in Wilmington became the center of the alpine events. Since then, World Cup and other ski and snowboard competitions have come to Wilmington on a regular basis.

In the late 1940s, Julian Reiss and his partners, artist and designer Arto Monaco and builder and promoter Harold Fortune, created Santa's Workshop. Upon its opening, the park made national and international news, creating a phenomenon. A photographic story hit the newspaper wires on July 5, 1949, and ran in over 700 newspapers across the country, resulting in even more stories, news, and magazine articles. The attendance figure on Labor Day 1951 was estimated at about 14,000 people. Santa's Workshop is still in operation today. Its introduction, along with that of the new ski area at Whiteface Mountain and the increased mobility brought about by America's new love of the automobile, caused motels to spring up all over town.

There is no longer evidence of the mills, forge, or factories that once dominated the West Branch of the AuSable River, nor is there much indication of past farming, except for a few stone walls hidden in the woods. In addition, the historic hotels have disappeared, and summer tourist cottages have turned into year-round homes. Forests once again cover most of the area outside of the hamlet portion of Wilmington. The original wooden bridge and dam has been replaced by a stone bridge, and a larger dam is located farther downstream. From its rural roots, Wilmington has evolved into an outdoor recreation, science, and education destination, featuring its natural attributes. The unique blend of natural resources, a touch of wilderness, entrepreneurship, and personal enterprise has created a small, rural town of national and international acclaim.

One

AGRICULTURE AND INDUSTRY

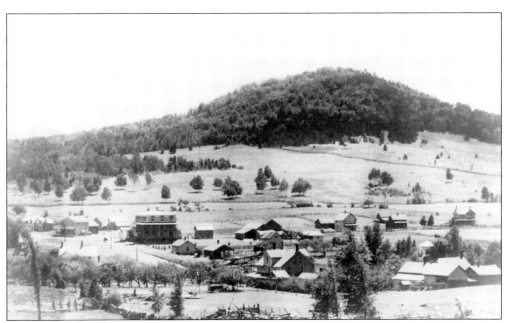

This 1912 view of Wilmington was taken from Bonnie View Road near the cemetery. Wilmington was a farming community in the AuSable River basin, and this photograph shows much of the land cleared for grazing pasture and crops. Some crops included apples, pears, potatoes, rye, and hops. The Whiteface Mountain House can be clearly seen along with other businesses and homes. (Courtesy of Guy Stephenson Jr.)

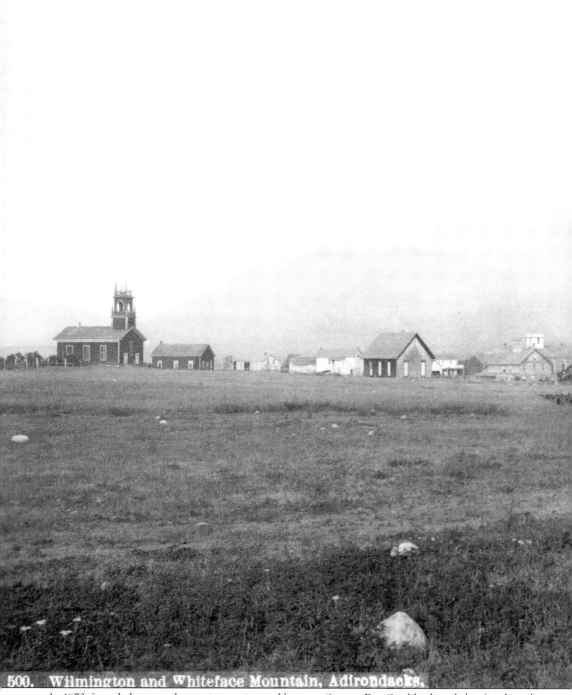

500. Wilmington and Whiteface Mountain, Adirondacks.

In 1873, famed photographer, writer, artist, and lecturer Seneca Ray Stoddard made his first lengthy photographic excursion throughout the Adirondack Mountains. Wilmington and Whiteface Mountain were on the tour. In this 1873 Stoddard panoramic view of the Whiteface Range with Wilmington in the foreground, the agricultural nature of the town is evident, with a few scattered houses, the Congregational church on the left, and the Methodist church in the center. In his

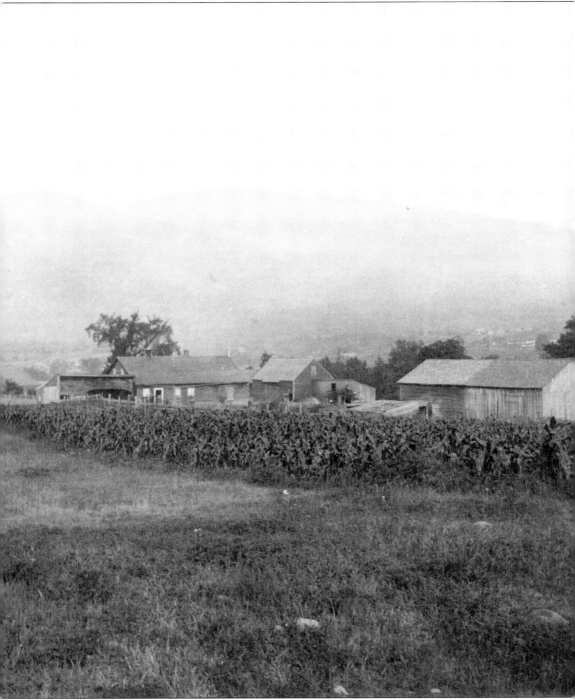

account of the journey, Stoddard describes "Old Whiteface" as "one of the finest mountain peaks in the Adirondacks." He tells of the ascent of Whiteface and of the passage through Wilmington Notch with humor, wit, and vivid description. Through his photographs, writings, and lectures, Seneca Ray Stoddard exposed the beauty of the Adirondacks. (Photograph by Seneca Ray Stoddard; courtesy of the Saranac Lake Free Library.)

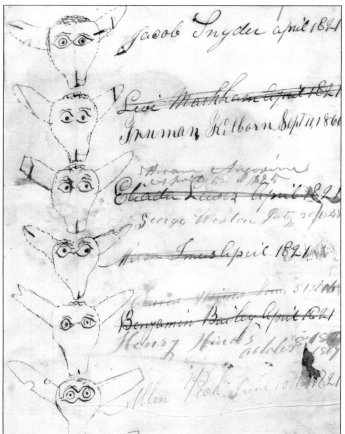

On this page from the *Wilmington Town Ledger 1821–1865* is a record of the brands of early Wilmington livestock. Ears of each resident's livestock were marked in a specific way to identify the animal's owner, and the key was recorded in the ledger. The crossed-off and rewritten names indicate livestock or brands that were sold or given to another resident. (Courtesy of the Town of Wilmington.)

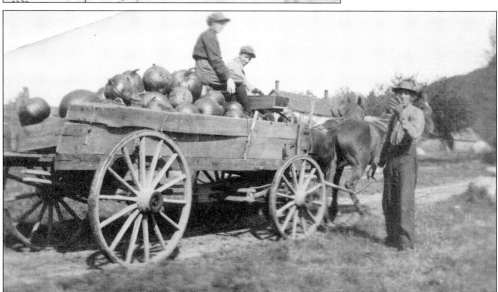

In this early-1900s photograph, a wagon full of pumpkins is seen during harvest at Winch's Mountain View Farm. Pumpkins were a staple vegetable for winter storage and use. Asher Winch is seen on the right. (Courtesy of Carol Latone, Winch Collection.)

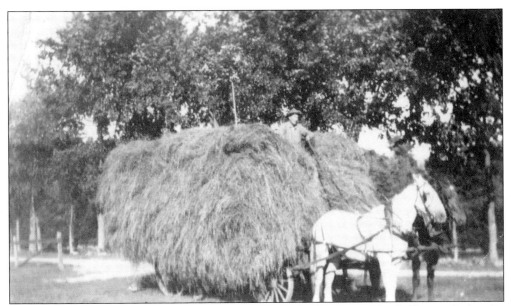

Guy H. Stephenson is seen here near the family farm with a large wagonload of hay in the hamlet of Haselton, also known as Markhamville, about 1915. Hay, which was used for feeding livestock, was stacked high in the wagons by a method called "racking" and brought to the barn to be stored for winter feed. (Courtesy of Celia Stephenson.)

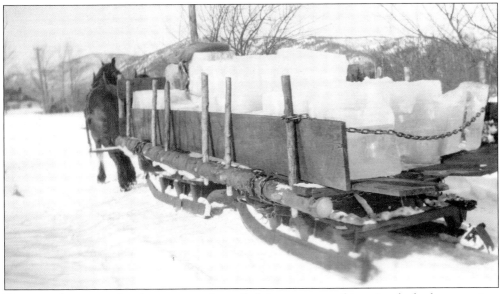

The natural resource of ice from area ponds supplied the necessary refrigeration for food preservation. Ice blocks were cut and then transported by horses with caulked horseshoes pulling wooden sleds, or "scoots," with side racks, or "pungs." Sawdust was used to insulate the icehouses for summer storage. (Courtesy of Douglas A. Wolfe.)

This c. 1915 image shows a typical self-sufficient farm family. Pictured are, from left to right, Guy Hamilton Stephenson; his wife, Mary Pelkey Stephenson, holding son Lawrence; Guy's mother, Alice Jaques Stephenson; and his sister Etta Stephenson Preston. This farm was located in Markhamville (now Haselton). All family members were expected to carry their share of farm work, and larger families meant more help. (Courtesy of Guy Stephenson Jr.)

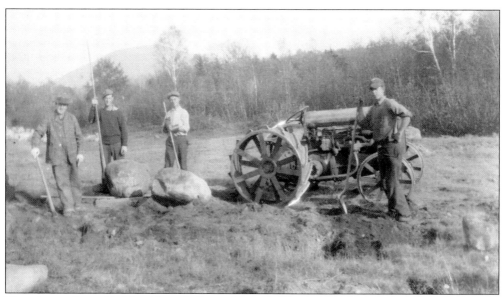

The glaciated, tumbled boulders challenged Jim Wolfe's work crew (pictured here in 1927) as well as Wilmington farmers. Equipment such as this 16-horsepower Fordson tractor was used to extract them from the fields. (Courtesy of Douglas A. Wolfe.)

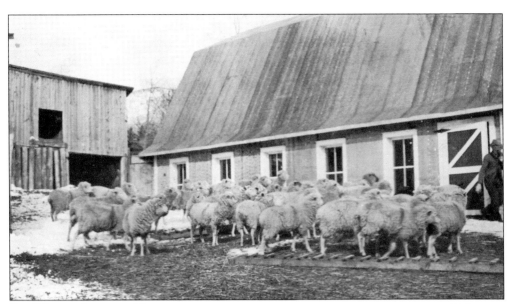

Small livestock was used for food, clothing, and mortgage chattel for local farmers. Sheep are seen in this 1927 photograph of the Bonnie View Farm. Wool, a cash product, was in demand during World War I. (Courtesy Douglas A. Wolfe.)

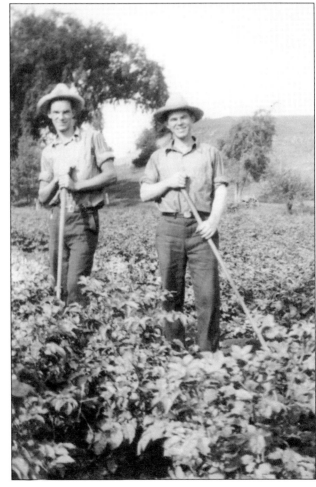

Earl Warren (left) and John Warren (right), brothers and hand laborers, are hilling potatoes on the farm in 1934. Multiple-generation farming families in Haselton included the Markhams, Fletchers, Haseltons, Warrens, Courtneys, Crowleys, and Stephensons. (Courtesy of the Haselton Lumber Company.)

15

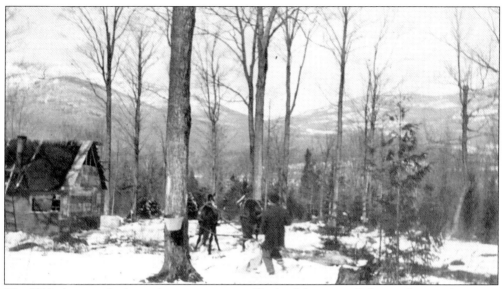

The 1915 photograph above shows sugaring on Quaker Mountain. Below is the sugarhouse on Bonnie View Road in 1957. Hardwood forests provided income for farmers by enabling production of charcoal and maple syrup. Trees in the maple grove, or "sugar bush," were tapped with spouts, and sap was captured in buckets. Good flows, or runs, of sap required daily gathering in tanks hauled first on horse-drawn sleds and later on tractors and "doodlebugs," vehicles whose wheel base was shortened by chopping or cutting the frame and drive shaft. The load was heavy, so careful route planning was necessary to transport the sap to the sugarhouse. The sap was boiled to syrup in a wood-fired evaporator, and it took about 30 gallons to make a single gallon of syrup. Further heating produced maple sugar, which was shared along with syrup at popular community "sugaring off" parties. (Above, courtesy of Suzanne Underwood Field; below, courtesy of Douglas A. Wolfe.)

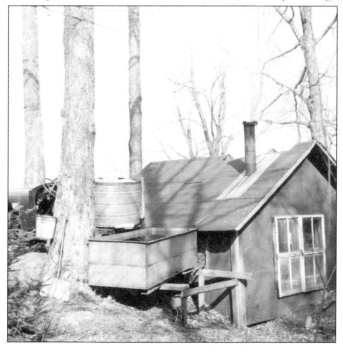

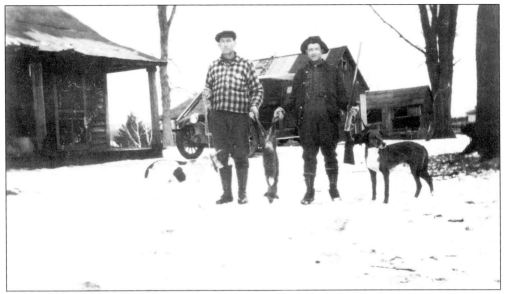

Here, at the Shea Farm in the hamlet of Haselton about 1920, Guy H. Stephenson and George "Grubby" Marshall are hunting foxes with dogs, as they did together for many years. Foxhunting was a pastime as well as a source of income; pelts were sold for cash. (Courtesy of the Allan Lawrence collection.)

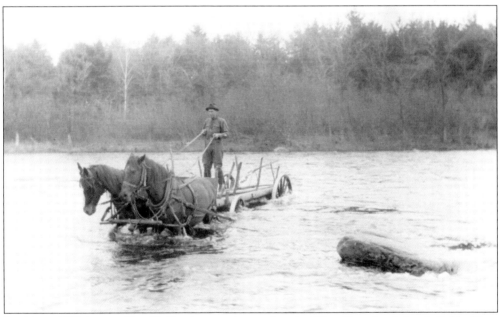

In this c. 1920 image, Guy H. Stephenson is crossing the West Branch of the AuSable River at the fordway approaching Haselton Road in the hamlet of Haselton. There was a suspension footbridge downstream from this crossing. Stephenson was on his way from the Shea Farm, where his brother Will Stephenson lived, to the Stephenson family farm on the Haselton side of the river. (Courtesy of Guy Stephenson Jr.)

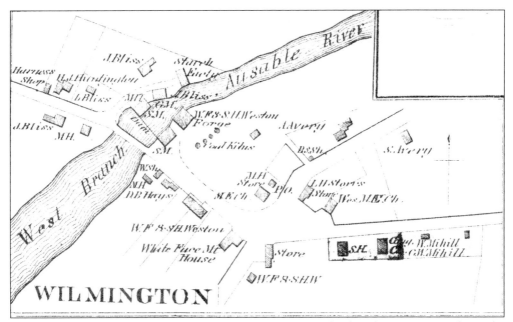

This map view, taken from the Gray's 1876 *New Topographical Atlas of Essex County*, shows the industrial center of Wilmington clustered around the dam. The abbreviations indicate an iron forge, a starch factory, a gristmill, two sawmills, charcoal kilns, and a blacksmith shop. Also marked are the Methodist Episcopal, Wesleyan Methodist, and Congregational churches; the village school; three stores; a post office; and the Whiteface Mountain House.

In 1920, a waterpower generator was installed at the dam in Wilmington. Financed by Frank Everest, it would provide electricity to his Whiteface Mountain House and eventually to the entire town. According to Donald Marshall's personal writings, during one spring thaw, timber floated down the AuSable River, jamming the waterwheel. Generator maintenance operator Gordon Marshall borrowed a tractor to power it until the debris was extricated. (Courtesy of Suzanne Underwood Field.)

18

Forest resources provided softwood trees for pulp and paper manufacturing. The J&J Rogers Company of AuSable Forks contracted with logging jobbers to cut, stockpile, and tally cords of pulpwood. The steep slopes dictated the 1897 construction of a unique two-and-a-half-mile log chute, or "slip," as seen in the 1920s photograph at right, as a means of safely moving the pulpwood down the mountain. Four-foot lengths were cut and stockpiled on headers along the route and in the source pond dam until spring thaw melt. The pulpwood was "slipped" down to the AuSable River and collected, as seen in 1920s photograph below, to be sent downriver to the mill. (Both, courtesy of Suzanne Underwood Field.)

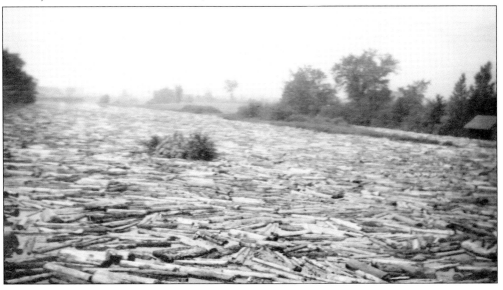

19

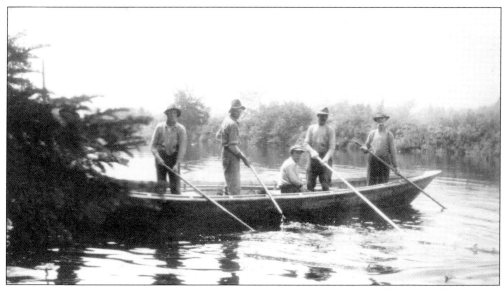

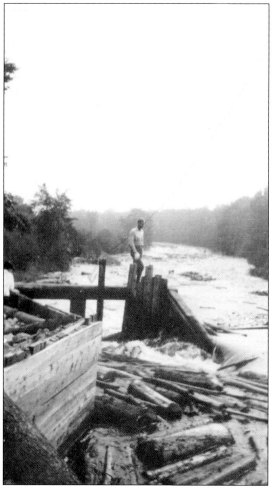

As seen in the c. 1920 image above, logging crews in special "jam" boats directed the pulpwood with pike poles. These boats had metal plates for protecting and reinforcing the bow and stern when hitting logs and stones in the river and could be rowed or poled when needed. A 1920s photograph at left shows the dam with the sluice gate open and pulpwood being fed through it to avoid jams and damage. The wood flowed approximately eight miles downstream to the pulp mill at the J&J Rogers Company in AuSable Forks. The spring snowmelt created high, fast water, and the wood moved downstream rapidly. This job of freeing log jams was dangerous work. The last drive was in 1923. (Both, courtesy of Suzanne Underwood Field.)

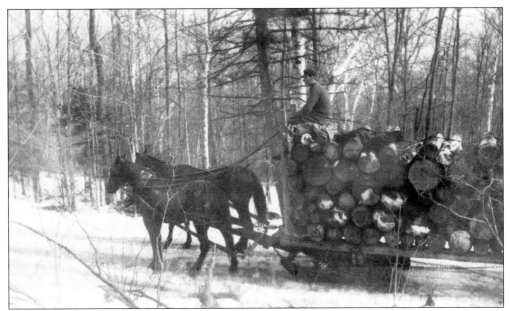

A teamster is driving a bobsled loaded with logs from a nearby lumber camp around 1900. This was a common mode of transporting logs during the winter months. (Courtesy of Carol Latone, Winch Collection.)

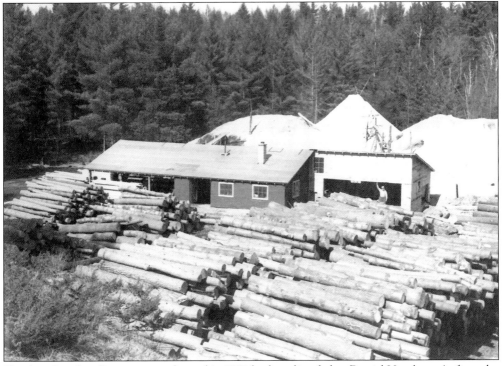

Haselton Lumber Company was formed in 1901 by founding father Daniel Haselton. At first, the mill operated with a steam engine and a horse-powered treadmill. In this 1944 image, logs are piled, waiting to be sawed into lumber. Levi Betters is standing in the doorway. (Courtesy of the Wilmington Town Historian, Helen Warren collection.)

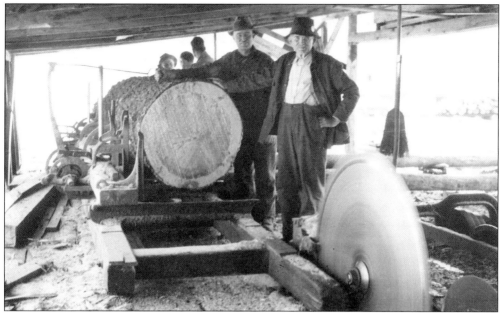

White pine, a common saw log, was quartersawn into rough lumber and then moved to a planing mill, where it became finished lumber. Pictured above in 1941 are, from left to right, Halsey Haselton, two unidentified men, Willard Haselton, and Dan Haselton. The later 1950 photograph below shows the planing mill with, from left to right, Dana Peck, Sydney Preston, Charlie Terry Sr., and William Stanley. (Both, courtesy of Haselton Lumber Company.)

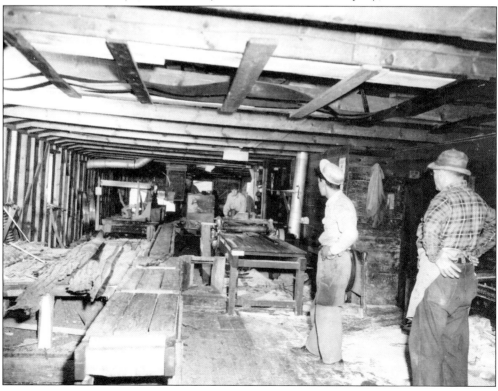

Two

WHITEFACE MOUNTAIN

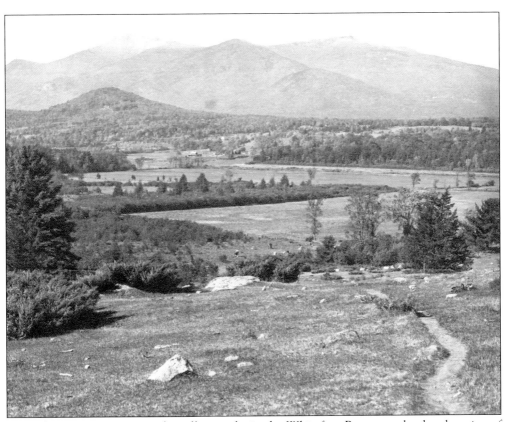

An early autumn snow atop the tallest peaks in the Whiteface Range marks the changing of seasons in this mid-20th-century photograph taken from Peck Hill near Route 86. Whiteface Mountain, the tallest mountain on the left, held the key in the transition from a 19th-century agricultural and industrial community to a 20th-century tourism-based economy. (Courtesy of Douglas A. Wolfe.)

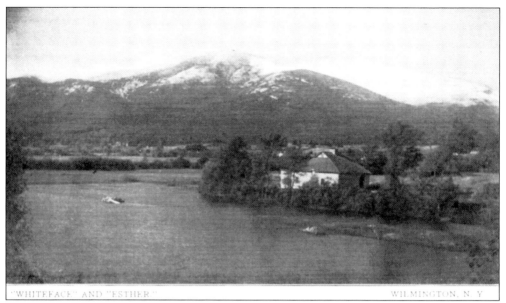

The Whiteface Range, composed of ancient anorthosite bedrock, includes Whiteface (4,867 feet/1,483 meters), adjacent Esther, and the lesser peaks of Little Whiteface, Lookout, and Marble Mountains. Esther, the only high peak having a feminine name, is named after a young girl who, in lore, independently and mistakenly climbed its summit instead of Whiteface in 1839. (Postcard photograph published 1908 by Ray Rowe; courtesy of the Wilmington Historical Society, Peter Yuro Collection.)

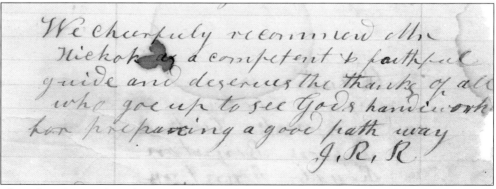

This July 1859 entry from the guest register at the Whiteface Mountain House is by a hiking party from Keeseville. Dr. J.R. Romeyn is endorsing their guide, Andrew Hickok Jr., and his newly cut trail up the east side. (Courtesy of the Wilmington Historical Society.)

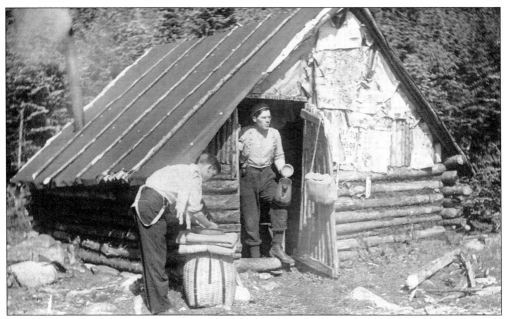

Local hotel owners foresaw an increase in hiking adventurers and, in 1870, constructed a rustic house at the highest water source, about one-half mile from the summit. This structure provided overnight shelter, at a cost, for sunset or sunrise viewing. Camp Welcome, as seen in this 1910 postcard, was operated by Ashley J. Maynard, seen in the doorway, while G. West adjusts the pack basket. (Courtesy of Cecile Maynard Dale.)

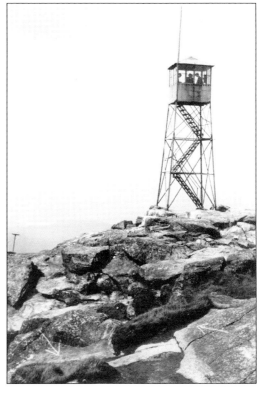

Adirondack forest fires prompted legislation creating fire wardens and lookout stations in 1909. Whiteface station, established that year, ran a telephone line from Lake Placid to the summit and down to the Wilmington Trail ranger cabin. The steel tower, installed in 1919, was removed in 1971 to be reassembled at the Adirondack Museum. (Photograph by D.P. Church; courtesy of Lamar Bliss, St. Lawrence University Collection, postcard collection of Robert Peters.)

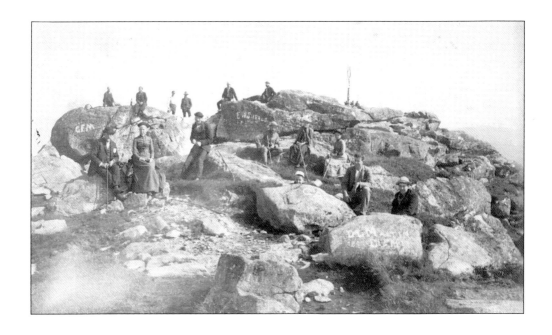

Early hiking parties to the Whiteface summit used everyday clothing and footwear, as pictured in the 1883 photograph above. In the c. 1900 image below, specialty items included pack baskets, rubber boots, raincoats, firearms, and a telescope. It was suggested that ladies wear pantaloons, not their crinoline. (Above, photograph by S. Wardner, courtesy of the Saranac Lake Free Library; below, courtesy of Carol Latone, Winch Collection.)

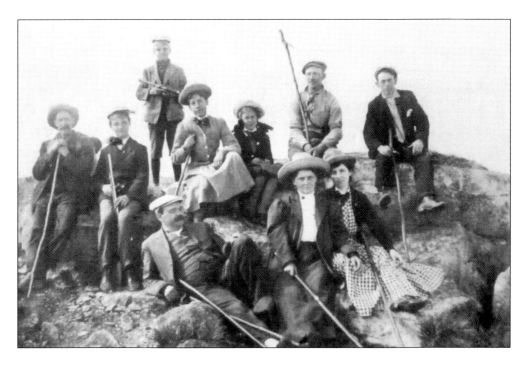

This house, which still exists, was built along the road connecting Wilmington to Franklin Falls. The pre-1929 photograph depicts the mountain road prior to construction of the Whiteface Mountain Veterans Memorial Highway. (Photograph by the Wilmington Chamber of Commerce; courtesy of Mary Shea Miskovsky, Smith Family Collection.)

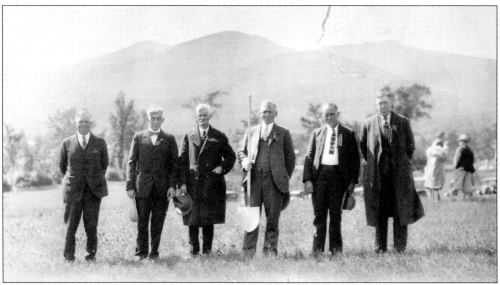

In 1922, local businessmen and politicians promoted a Whiteface motor road. Private, state, legislative, and voter approval was completed in 1927. On September 11, 1929, Gov. Franklin Roosevelt inaugurated the project. Actual construction was delayed until 1931. Pictured here from left to right, Wilmington board members Halsey Haselton, William G. Cooper, William Richardson, Wilmington Town supervisor Charles Taylor, Justice Abram Kilburn, and Earl McLeod display the ceremonial shovel. (Courtesy of the Wilmington Town Historian.)

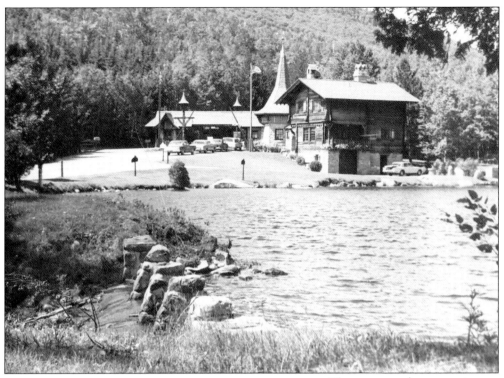

The motor road construction bonds backed by the state comptroller were to be paid back by tolls collected. An alpine-style tollgate house was constructed in 1934 after a design competition within the state public works department. The original pulpwood dam and pond were rebuilt and named Lake Stevens in honor of J. Hubert Stevens, the first highway commissioner. (Courtesy of Douglas A. Wolfe.)

Walter Weeks, a long-term superintendent of the Whiteface Memorial Highway, welcomed visitors to the mountain. The summer season toll rates were $1 per person, with children's rate at 50¢. Pres. Franklin Roosevelt commented, "See the Adirondacks for a dollar." (Courtesy of the Lake Placid Olympic Museum.)

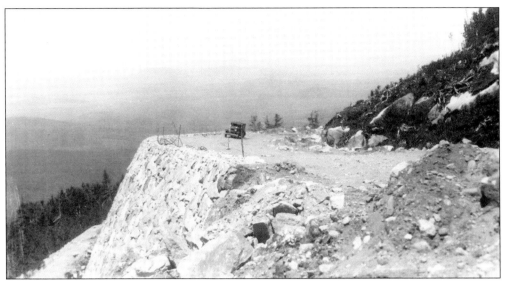

Roadway construction challenges included extensive ledge rock, steep slopes, and water runoff ravines. Excavated rock was recycled into dry-fit support walls and fill, topped by a mortared masonry guard wall with a rough stone cap to complement the mountain features. (Courtesy of the Marshall family.)

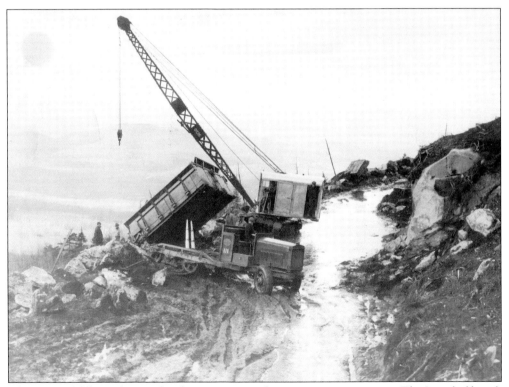

The "cut and fill" roadway utilized various types of construction equipment. The Linn half-track hydraulic dump truck and a Byers crane are accurately placing rock wall material. (Courtesy of Douglas A. Wolfe.)

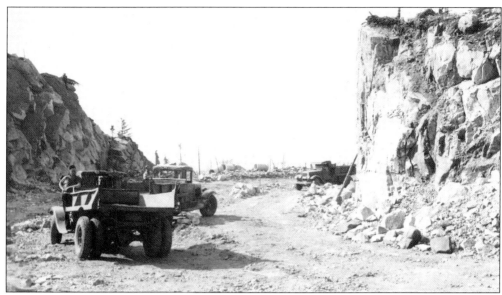

At the 4,000-foot elevation, the Everest (or Lake Placid turn) switchback required a large excavation cut. Extensive drilling and blasting eventually opened the area and provided fill for the roadway base. Here, contractor dump trucks are hauling debris. (Photograph by D.P. Church; courtesy of Lamar Bliss, St. Lawrence University Collection, postcard collection of the Marshall family.)

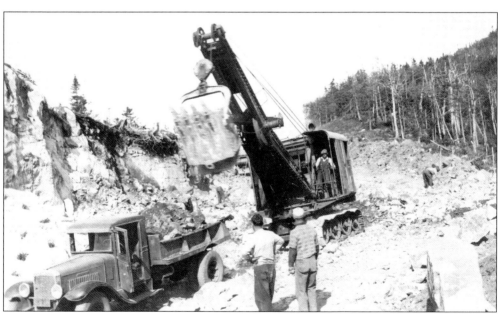

The switchback debris was loaded with Lorain 45-B gas shovels into various contractor dump trucks. At $1.10 per hour, the shovel operator was the highest paid worker. The extra pay was earned, however, as the job required the use of many levers and pedals to control the rotary, boom, dipper stick, and bucket trapdoor while avoiding damage to trucks. (Photograph by D.P. Church, courtesy of Lamar Bliss, St. Lawrence University Collection, postcard collection of the Marshall family.)

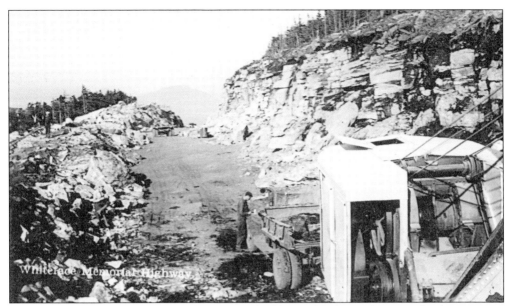

Final upper roadway areas required extensive buildup and ledge rock removal. This area was frequently in cloud, with wind-chilled temperatures, and progress was slow. (Photograph by D.P. Church; courtesy of Lamar Bliss, St. Lawrence University Collection, postcard collection of Robert Sturges.)

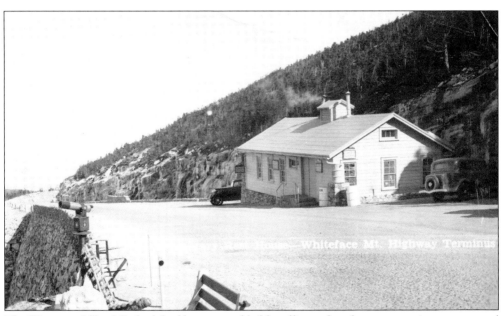

The "Engineers' Shack," which had been assembled for office and work crew operations, was moved to the parking area to provide facilities—including restrooms and a souvenir shop—while the "Castle" (the upper tollhouse) was being built in 1936. It was relocated to the 4,400-foot level and was used by the atmospheric science center from 1961 through 1966. It was eventually demolished in 1972. (Courtesy of the Marshall family.)

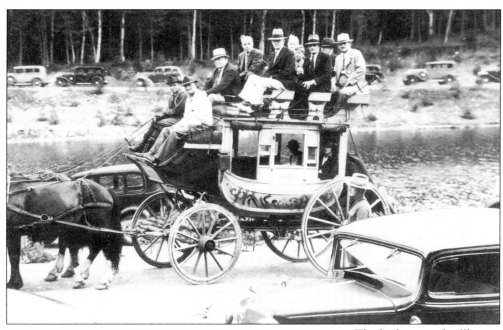

The highway and tollhouse were officially opened for tourists on July 20, 1935. The first vehicle was a historical Concord stagecoach with several local dignitaries on board. Governor Lehman, chief engineer F.S. Greene, and other involved officials gave speeches highlighting the courageous effort and successes involved in the accomplishment of such a project. (Courtesy of Winnie Lamb.)

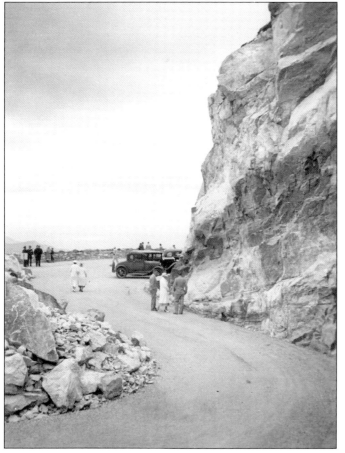

In 1935, the 4,600-foot highway terminus looped automobiles back downhill for diagonal parking along the ledge wall. Barrels of water for overheated radiators were provided. A highway patrol augmented the mountain staff. (Courtesy of the Saranac Lake Free Library.)

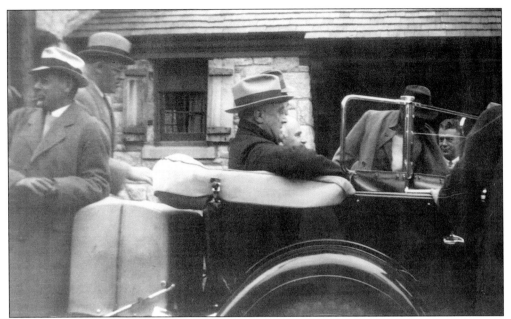

The motor road was officially dedicated as a memorial highway on September 14, 1935, by Pres. Franklin D. Roosevelt. A young schoolgirl, in attendance with her music teacher, took this photograph after previously trying unsuccessfully and being shooed away by Secret Service agents. (Courtesy Douglas A. Wolfe.)

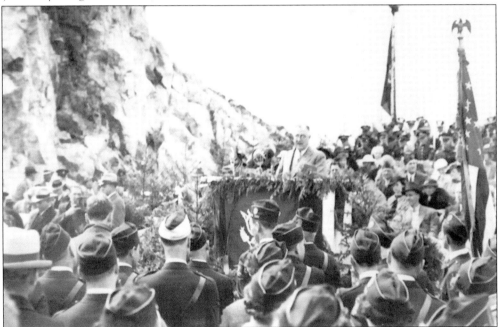

In his formal dedication of the highway to World War I veterans, Pres. Franklin D. Roosevelt commented, "This is one of the finest things that the state of New York has ever done." His remarks were transmitted to Lake Placid via an experimental General Electric pulsed visible light converter, the predecessor to modern microwave transmission. (Courtesy of the Wilmington Historical Society, Jean Tanton Huntington Collection.)

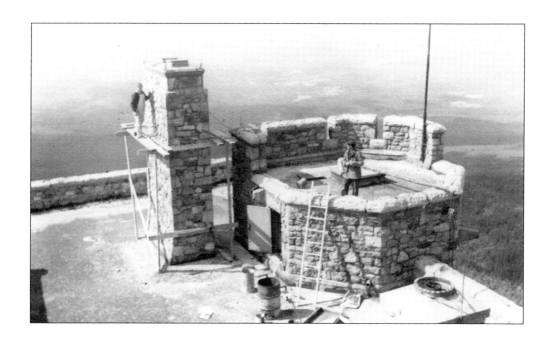

Work on the final design of the upper tollhouse was started in 1936 to provide shelter. Water for restrooms and food services was pumped up from a dam at 3,000 feet to a storage tank. The structure earned the nickname "Castle" because of its unusual stone construction. Above, stonemason George Marshall (left) works on the fireplace, and his colleague Howard Peck (right) works on a wall. Shown in the 1937 photograph below are the arched drive-through portals and graceful stone columns of the west side viewing area. The Castle housed the restaurant, restrooms, souvenir shop, and administrative office. (Above, courtesy of the Marshall family; below, courtesy of the Saranac Lake Free Library.)

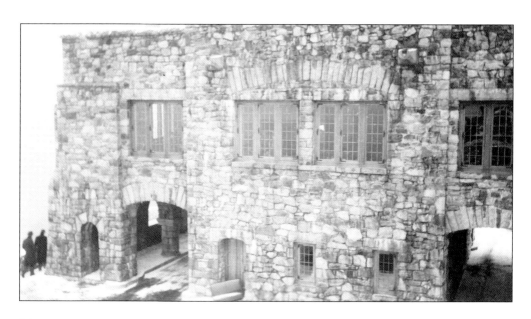

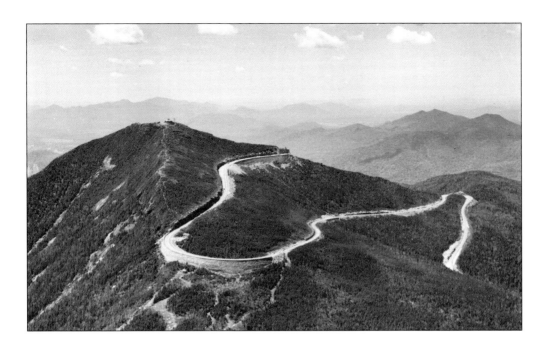

As seen in the aerial view above, the Memorial Highway was New York's first paved recreational motor road providing access to a mountain environment heretofore available to only a few. President Roosevelt commented, "[For] age of life . . . and millions of people who have not the facilities or possibilities of walking up . . . we have provided one mountain that they can go to on four wheels," as is evident in the 1930s image below. (Above, courtesy of the Olympic Regional Development Authority; below, courtesy of the Saranac Lake Free Library.)

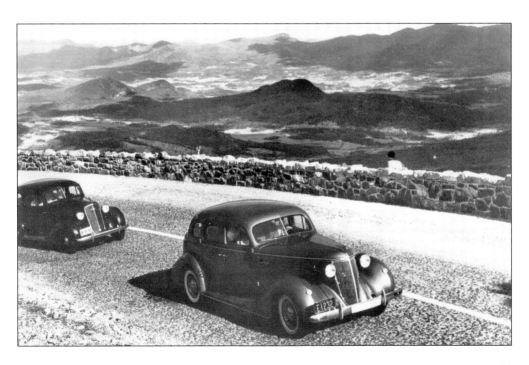

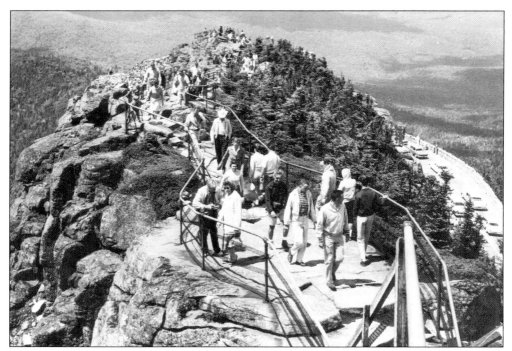

The motor road terminated below the peak and required a hiking adventure up the ridge or arête nature trail, as shown above. Construction on a proposed tunnel, or adit, and elevator shaft began in 1936, and breakthrough occurred in June 1937. The elevator machine, pictured below, went into service in July 1938. The tunnel length of over 400 feet and the shaft height of 27 stories give an inside view of the mountain's geology. The shaft drilling from the bottom up, called "stoping," used debris muck for staging and a narrow-gauge mine cart railroad carried the tailings out. Drilling and blasting from the top down provided stone for the building and walkways. (Above, courtesy of the Saranac Lake Free Library; below, courtesy of the Marshall family.)

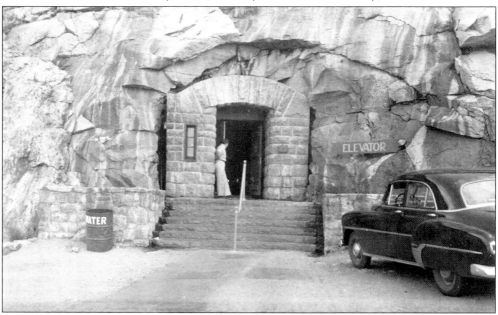

Whiteface, with an elevation of 4,867 feet (1,483 meters), is the fifth highest Adirondack Peak. However, it is the only one with a highway and elevator allowing access to the peak, where young John F. Dreissigacker is seen in this photograph from 1958. Special silhouette signs were designed to display various elevations and facts about the highway. (Courtesy of the Olympic Regional Development Authority.)

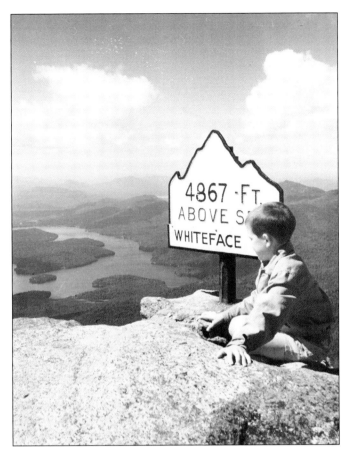

The final structure approved and built was of circular design with stone buttresses and a wide walkway with a stone parapet wall complementing the mountain environment. Provision was made for a fire lookout atop, but it was not suitable, and the 1919 tower remained. (Courtesy of the Olympic Regional Development Authority.)

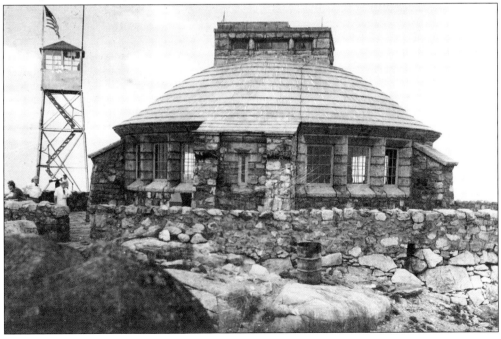

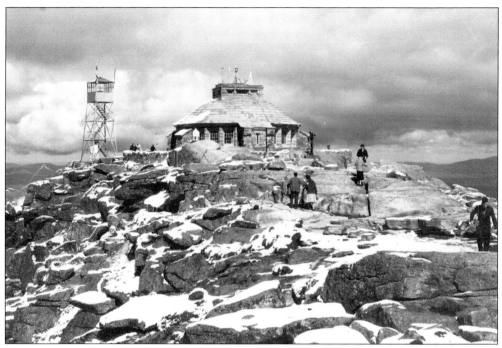

The treeless summit area provided grand vistas and the opportunity to examine the geology of the mountain's exposed bedrock. Area veteran organizations installed the memorial light atop the Summit House in 1952. (Courtesy of the Olympic Regional Development Authority.)

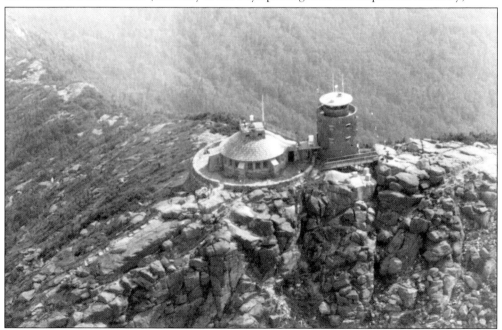

The Summit House was altered in 1970 with the addition of a new weather and research observatory, which incorporated the fire lookout tower. The State University facility reestablished the former weather station used from 1937 to 1946 as a long-term scientific base. (Courtesy of Douglas A. Wolfe.)

Scientific measurements and surveys—by Verplank Colvin in 1872 and others since—used the mountain as a reference base. Weather observations were taken during the fire-lookout season, and colleges and universities reestablished programs for meteorological data and environmental research in cooperation with various state agencies. (Courtesy of the Olympic Regional Development Authority.)

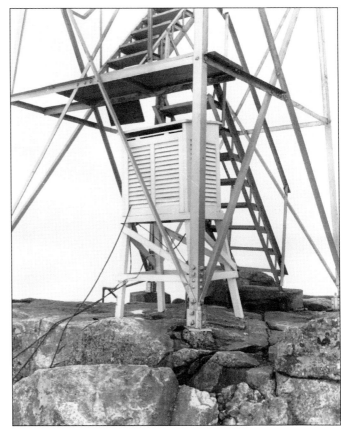

Atmospheric sampling of gases and particulates provided information on airflow transport from great distances. Frozen cloud water, or rime ice, also provided information on a cloud's chemistry and journey. (Courtesy of Douglas A. Wolfe.)

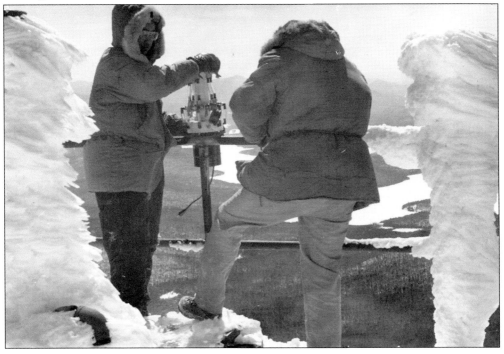

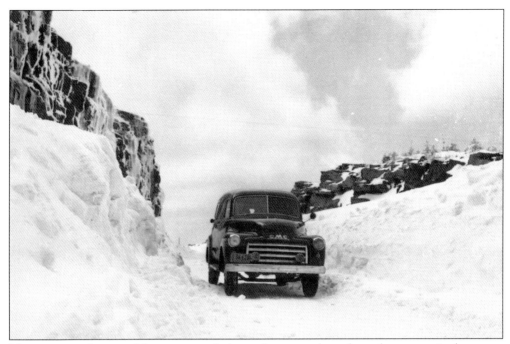

Mountain winds created large accumulations of snow, and much work was required to open the roadway for the season. Here, a 1952 state vehicle descends through the highway snow cut. (Courtesy of Douglas A. Wolfe.)

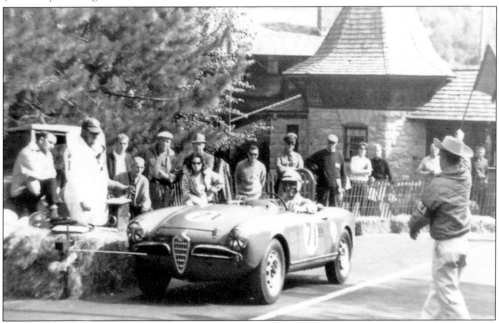

Bruce Cargill is at the start line in his Alfa Romeo during the first and only Whiteface Mountain Championship Sports Car Hill Climb in 1964. His time for the 4.7-mile course was 4:09:40. Norm Evenden set the record time of 3:17:96, driving his Cooper-Chevy with an average speed of 85.5 miles per hour. (Courtesy of Greg Rickes, Team McClumpha Archives, Mohawk-Hudson Chapter of the Sports Car Club of America.)

Three

WHITEFACE SKI AREA

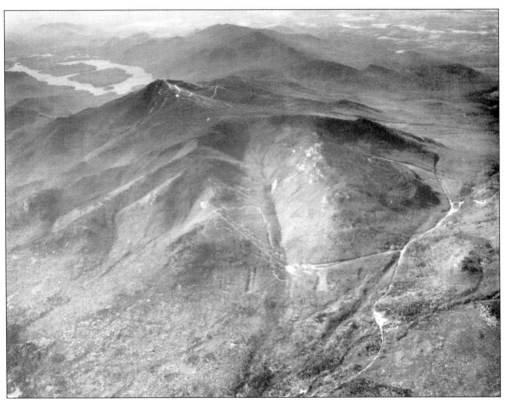

The 1836 scientific survey of Whiteface described an isolated peak with steep slopes and unusual flora. The grand views offered great tourism potential. (Courtesy of the Wilmington Town Historian.)

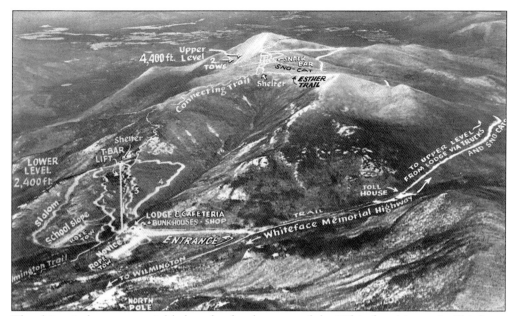

The skiing industry potential led to the development of the Whiteface Mountain Ski Area, incorporating Marble Mountain, adjacent to the Memorial Highway, as pictured above. The process included a constitutional amendment in 1941 and the creation of the Whiteface Mountain Authority in 1944 to issue bonds and operate the area. Postwar construction started in 1947, with early trail designers Hannes Schneider and Otto Schniebs working on the alpine trails and Herman Smith-Johannsen working on the upper cross-country trails. E.S. Constam planned the T-bar lift and appurtenances for the lower area. The area opened in 1948, was dedicated in 1949, and operated until 1960. The 1951 log structure pictured below, constructed of salvaged 1950 Adirondack blowdown timber, replaced the burned 1948 lodge. An atmospheric center currently uses the facility. (Above, courtesy of Guy Stephenson Jr.; below, courtesy of the Olympic Regional Development Authority.)

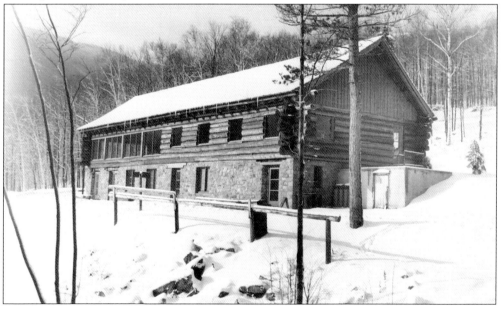

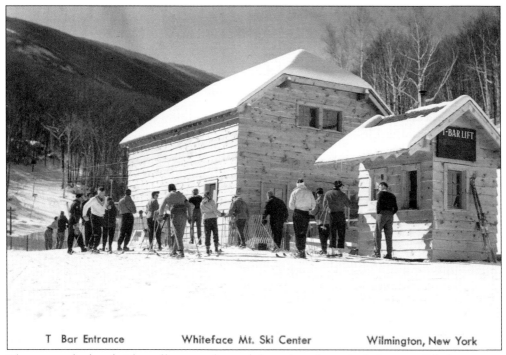

T Bar Entrance Whiteface Mt. Ski Center Wilmington, New York

The motor shed and ticket office were located downslope from the lodge on a filled area over White Brook, which was routed through large culverts. A rope tow boost was required to return up to the lodge. (Courtesy of the Wilmington Historical Society, Laurie J. Bepler Collection.)

The rope tow areas included the practice slope off the lower driveway, seen here, and the bunny slope uphill from the garage and parking lot. As the area was a public watershed, warnings were posted about proper sanitary discipline. (Courtesy of Carol Latone, Winch Collection.)

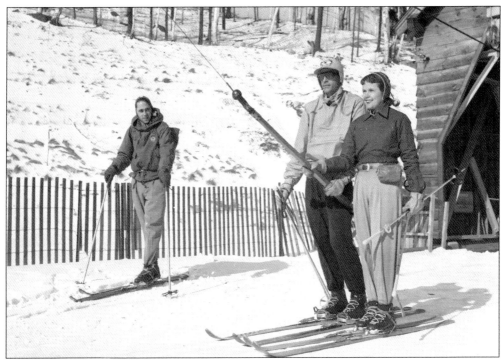

The Roebling-Costam T-bar lift, seen above, had a length of 3,300 feet with a vertical rise of 900 feet. Exit areas along it gave additional access to trails. The T-bar lift was removed in 1967, and the rope tows were recycled to other area ski centers. The Memorial Highway was incorporated as access to upper rope tows at 4,400 feet of elevation. When the route could be plowed, transport to the location involved four-wheel-drive trucks, as seen below. When plowing was not possible, the alternative was a snowcat, costing $1.50 per ride. The descent from the summit through the Marble area to Wilmington could be made via old hiking trails, or travelers could return by the Memorial Highway. (Above, courtesy of the Olympic Regional Development Authority; below, courtesy of Douglas A. Wolfe.)

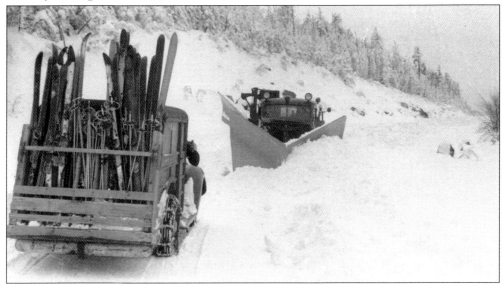

The Marble Mountain location had limited possibilities for expansion and access; thus, early promoters revisited the east bowl in 1955 and conducted snow surveys in addition to cutting a test trail, Cloudsplitter, from the Memorial Highway down the east bowl, as shown right. Active promotion and legislative funding saw rapid development of this location, with two chairlifts—designated "Valley" and "Mountain"—and a rope tow constructed in 1957. Future expansion would include T-bar, Poma, triple, and high-speed quad lifts and an enclosed gondola lift. Army ski veteran Don Adams, seen below, continued the area's expansion during his tenure as manager. (Right, photograph by Richard K. Dean; both, courtesy of the Olympic Regional Development Authority.)

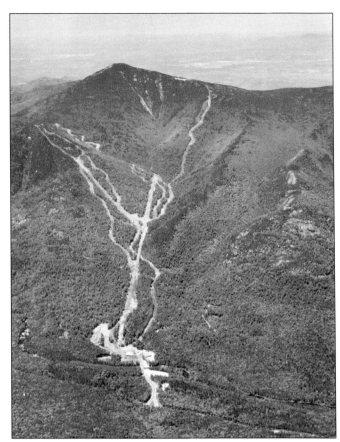

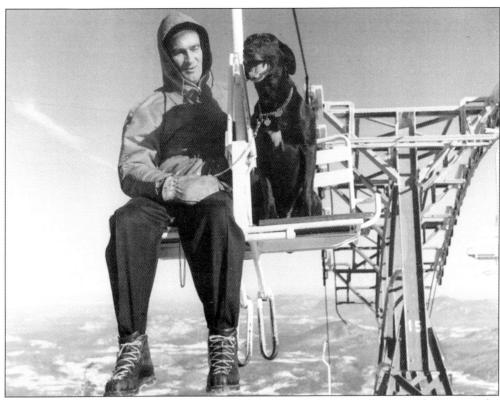

Arthur Draper, a World War II medic with the US Army 10th Mountain Division Ski Troops, rides the chairlift with his dog Patch. Art, the first supervisor of the Marble Mountain Ski Center, later helped with the development of Gore and Belleayre Mountain Ski areas. In 1958, he returned to Wilmington to become the supervisor of the new ski center. (Courtesy of the Olympic Regional Development Authority.)

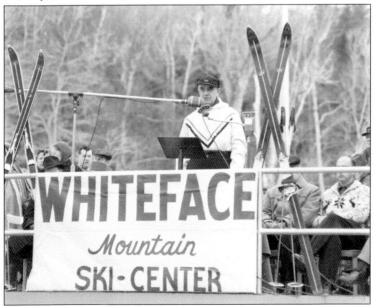

Gov. Averill Harriman officially dedicated the new skiing area to the 10th Mountain Division of World War II on January 25, 1958. He had been a western ski area developer and signed legislation to finance the relocation of the Whiteface Ski Center. (Courtesy of the Lake Placid Olympic Museum.)

In the c. 1950 photograph at right, Otto Schniebs, known as the "father of United States skiing," is seen (left) with actor Kirk Douglas (right). Schniebs, who emigrated from Germany in 1927, is credited with popularizing alpine skiing in America by revolutionizing ski instruction. He authored three books on skiing technique, manufactured a line of Sohm's ski wax in Wilmington, and was a prominent ski instructor, coach, and promoter. In 1938, he and Hal Burton from Keene laid out a Class A downhill racing trail with a 2,700-foot vertical drop on Little Whiteface, laying the groundwork for a future ski center. In the photograph below, Otto assists a customer at his Whiteface Mountain ski shop around 1958. Otto exclaimed, "Skiing is not a sport; it is a way of life!" (Right, courtesy of Camilla Palumbo; below, courtesy of Douglas A. Wolfe.)

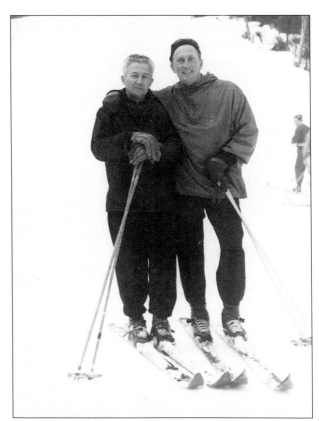

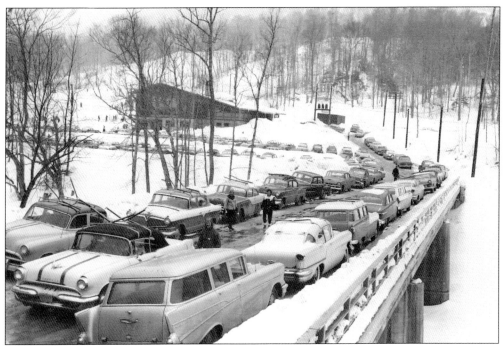

As pictured above, the infrastructure required a new bridge over the AuSable River, which was used for additional parking. Below, on busy days, racks and safe storage were needed to prevent unintended runaway skis. (Both, courtesy of the Olympic Regional Development Authority.)

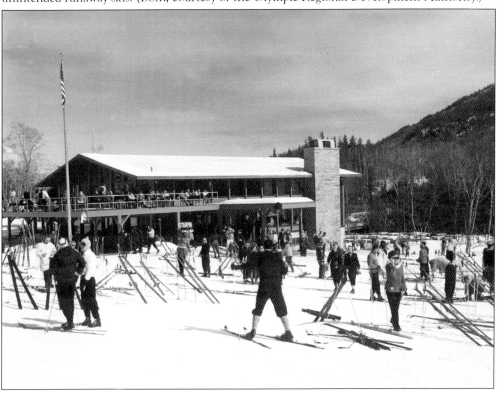

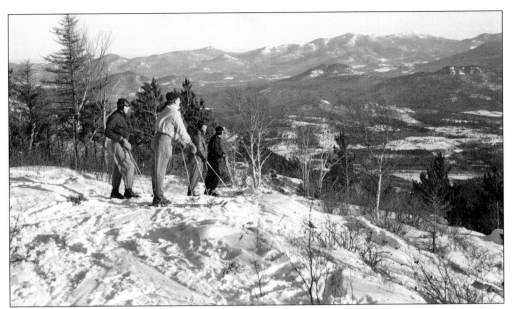

Vista lookout areas provided pleasant rest and viewing sites for the full enjoyment of the winter alpine experience. Views overlooking Wilmington and the AuSable River valley can be seen here. (Courtesy of the Olympic Regional Development Authority.)

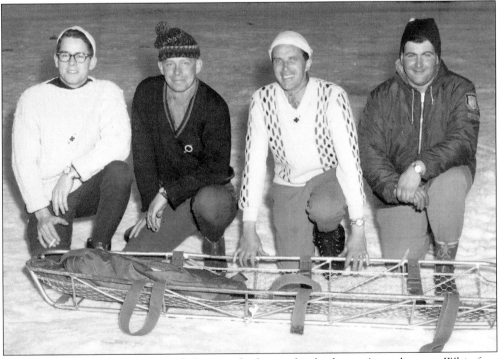

The ski patrol provides an essential element of safety to the ski slopes. According to a Whiteface Mountain Authority memorandum, the men pictured here won the coveted United States Eastern Amateur Ski Association pin for the Whiteface Ski Patrol in 1963. They are, from left to right, Jon Twichell, Al Risch (of Jackson, New Hampshire), Fritz Heider, and Wally Pulsifer. (Courtesy of the Lake Placid Olympic Museum.)

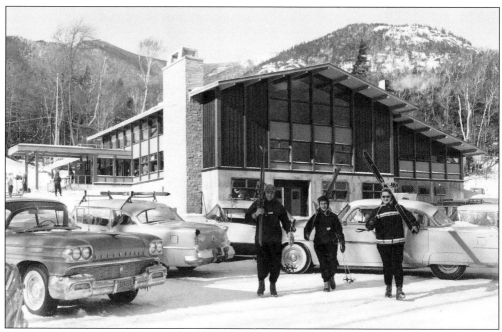

Above, the base, called "Draper Lodge," provided food services, restrooms, ski sales, rental and repair shops, first aid services, administrative offices, and a large common cafeteria area with a copper-hooded fireplace and wall displays of various ski-club emblems. Chairlift One, the "Valley" lift, was a Riblet Tramways double-seat lift, as shown in the photograph below. The total cable length was 6,200 feet, which traversed the contours of the mountain. There was a midstation exit platform for Lift Two, or the "Mountain" lift, to Little Whiteface Summit. (Above, courtesy the Olympic Regional Development Authority; below, courtesy of the Lake Placid Olympic Museum.)

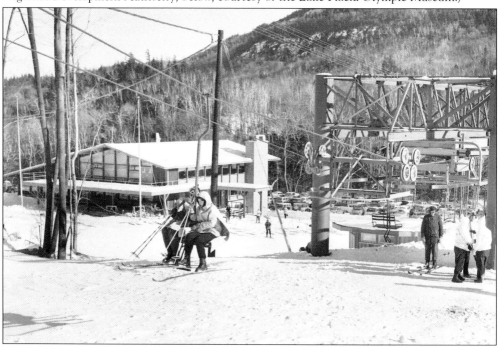

Many dignitaries visit the area, including, in 1965, various Kennedy family members. At right, Jacqueline Kennedy is approaching the Midstation exit platform. The Midstation Lodge, built in 1961, provides an on-the-mountain respite for skiers. Early ski councils foresaw the value of youth- and school-involvement programs. Youths, such as the young Caroline Kennedy (below), received personal instruction. Eventually, complete facilities, or "Kids Kampus" areas with supervised indoor and outdoor activities, were developed. (Both, photographs by Fitz-Gerald's Photograph Studio, Jay, New York; courtesy of the Olympic Regional Development Authority.)

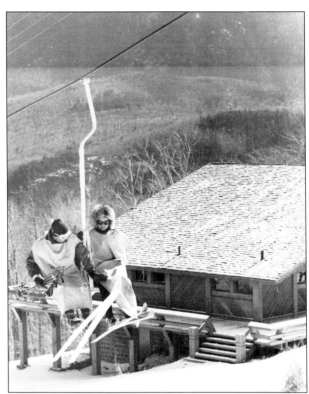

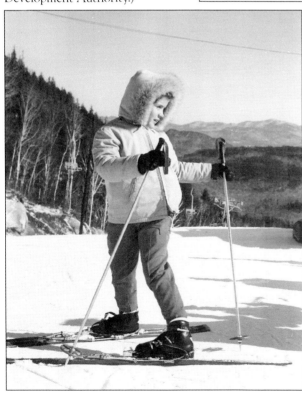

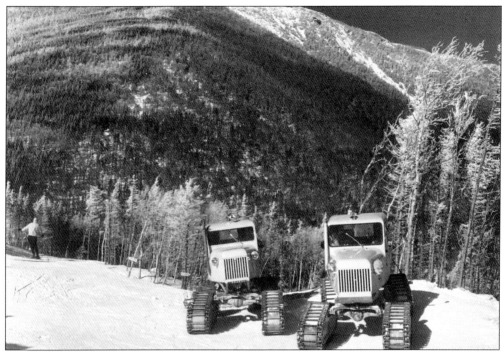

In both of these photographs, the steep, snowy slopes of 1958 required special vehicles for transportation and support work. The tracked Tucker over-snow vehicles were used extensively to perform packing and spreading operations in fresh snow with rollers and drags, thus ending the old side-step method by volunteers on skis. In the photograph below are, from left to right, unidentified, Paul "Nick" Stephenson, Joe McLean, and Halsey Bushey. (Both, courtesy of the Olympic Regional Development Authority.)

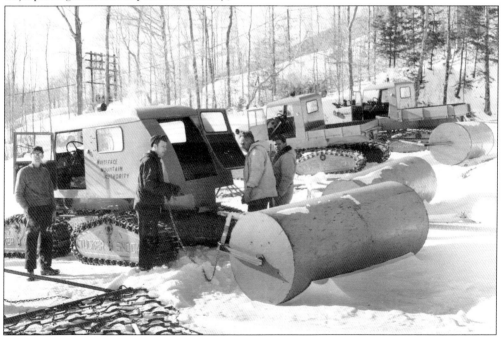

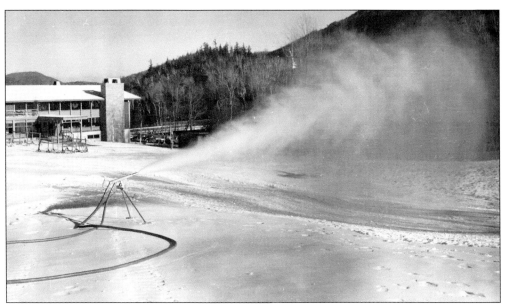

Controlled snowmaking lessened the reliance on natural snowfall. In these two 1960s photographs, the early units used compressed air and water to form frozen droplets. Technical improvements and equipment changes occurred rapidly, and the 1980 Olympic alpine events were staged entirely on man-made snow. "Snow farming," or grooming, was improved with new equipment that involved hydraulics, grading blades, and specialty implements. (Both, courtesy of the Olympic Regional Development Authority.)

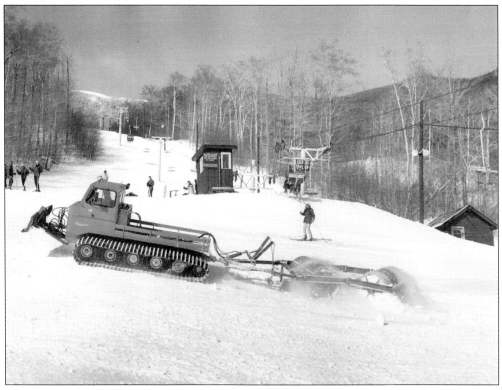

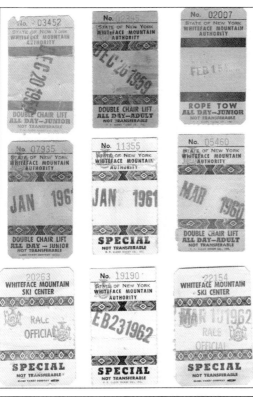

The ski industry generates income through daily and seasonal-use ticket sales. The original 1948 Marble Area season ticket was $35 or $3 a day for T-bar and rope tows, with a charge of $1 plus tax for a snowcat machine ride to the upper levels. First-day tickets in January 1958 cost $5 for a 10-ride ticket, and in 1967, the season pass reached $100. (Courtesy of the Olympic Regional Development Authority.)

The mountain environment and steep slopes made on-site repairs difficult. Shown here are, from left to right, Wally Pulsifer, Dana Peck, foreman Charles Barry, and Alvin Mason, working a cable splice at Valley Lift above Midstation. (Courtesy of the Olympic Regional Development Authority.)

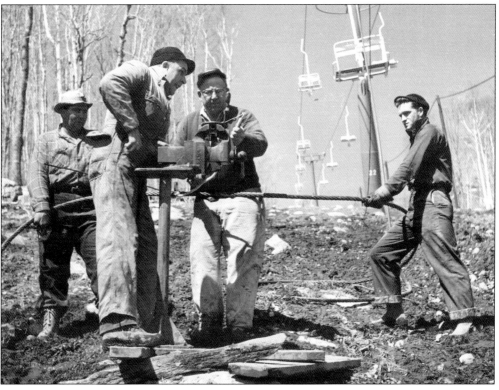

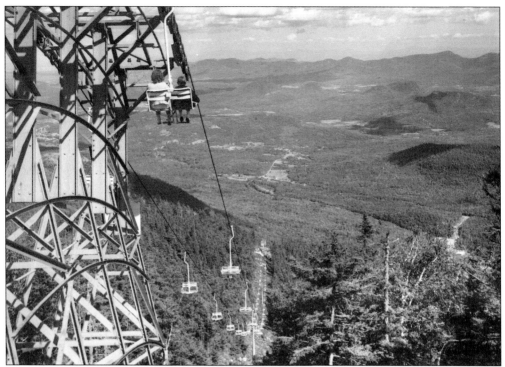

The transition tower atop Little Whiteface marked the ride's end and provided broad vistas of Wilmington and the Champlain Valley, as seen above. Below, a nonhuman rider—the Liftsonde portable weather-recording station—measured weather parameters while traveling up and down. Ray Falconer and James Brower of the Atmospheric Science Research Center created the 1961 project equipment. (Above, courtesy of the Olympic Regional Development Authority; below, courtesy of Douglas A. Wolfe.)

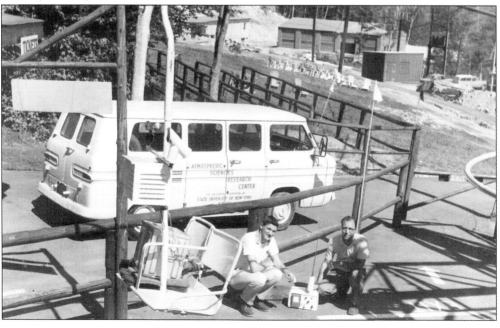

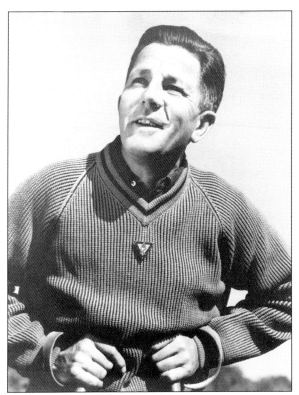

Pictured at left around 1960, Swiss-born Walter Prager was the first world-champion downhill skier at the 1931 championships held in Switzerland. He immigrated to the United States in 1936, coached skiing at Dartmouth College, and volunteered during World War II to teach skiing and mountaineering to the Army mountain infantry, which later became the 10th Mountain Division. After serving in Italy, he coached the US Olympic ski team in 1948. He established the Maison de Ski shop in Wilmington in 1960 and was inducted into the National Ski Hall of Fame in 1977. Prager often hosted international skiers. Pictured below are, from left to right, Walter Prager, Mrs. Rikhye, Eleanor Prager, and Maj. Gen. Indar Rikhye of India, military advisor to the United Nations' secretary general. (Left, courtesy of Gail Prager; below, courtesy of the Lake Placid Olympic Museum.)

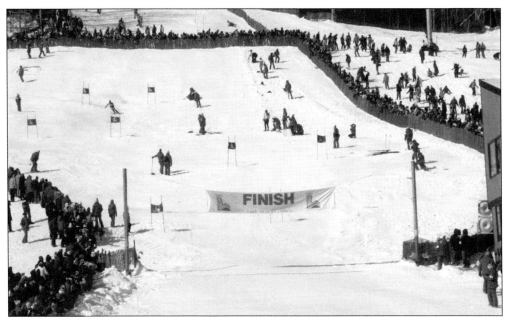

Whiteface Mountain was the alpine ski venue for the 1980 Winter Olympics. The Olympic downhill and giant slalom racecourses finished at the 1,600-foot-level chairlift tower 10 area. The downhill length was one and nine-tenths of a mile, with a vertical drop of one-half mile. (Courtesy of Jeri Wright.)

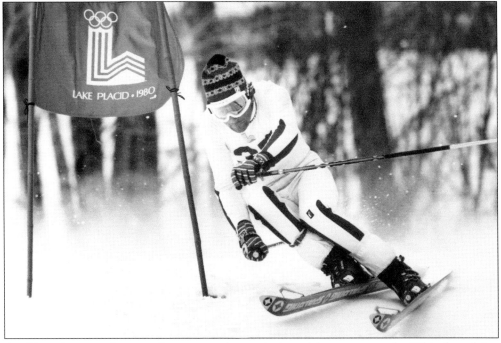

An Olympic competitor rounds a gate on the men's giant slalom course at the Whiteface alpine venue. Alpine skiing at the 1980 Winter Olympics consisted of six events held from February 14 to February 23. This was the last winter Olympics to also serve as the world championship event for alpine skiing. (Courtesy of the Lake Placid Olympic Museum.)

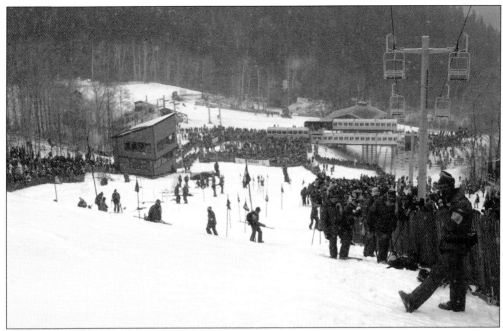

The Olympic slalom course on the Mountain Run Trail was three-tenths of a mile in length. It descended 500 vertical feet to the finish at the Midstation Lodge area. (Courtesy of Jeri Wright.)

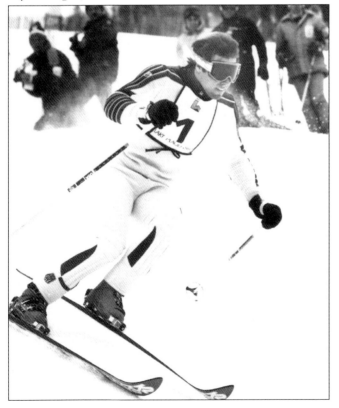

American Olympian Phil Mahre, in bib No. 1, skied to a silver medal in the men's slalom event on February 22, 1980. Ingemar Stenmark of Sweden took the gold in both this event and giant slalom. Phil Mahre was also awarded the world championship gold medal in the combined events for this Olympic run added to the results of his Olympic downhill run. (Courtesy of the Lake Placid Olympic Museum.)

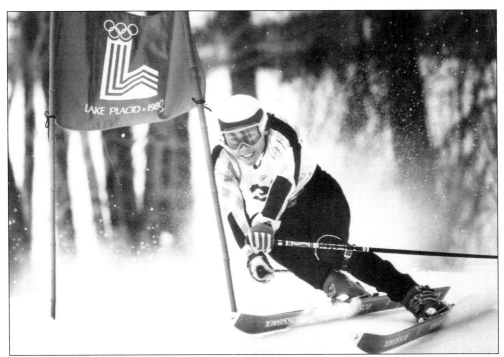

An Olympic contender skis down Whiteface in the giant slalom event. The XIII Winter Olympics was the first in which the women's giant slalom included two runs, rather than one. Hanni Wenzel of Liechtenstein won the gold in both women's slalom and giant slalom and also took the silver in women's downhill. (Courtesy of the Lake Placid Olympic Museum.)

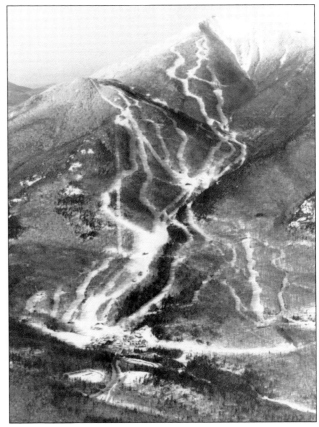

The third winter Olympic Games, held in 1932 in Lake Placid, had no alpine skiing events, in contrast with 13th games, held in 1980. The Whiteface Mountain Ski Center in Wilmington emerged as a world-class host with new infrastructure upgrades capable of supporting any future opportunities, and it remains a valuable asset of New York State and the nation. (Courtesy of the Olympic Regional Development Authority.)

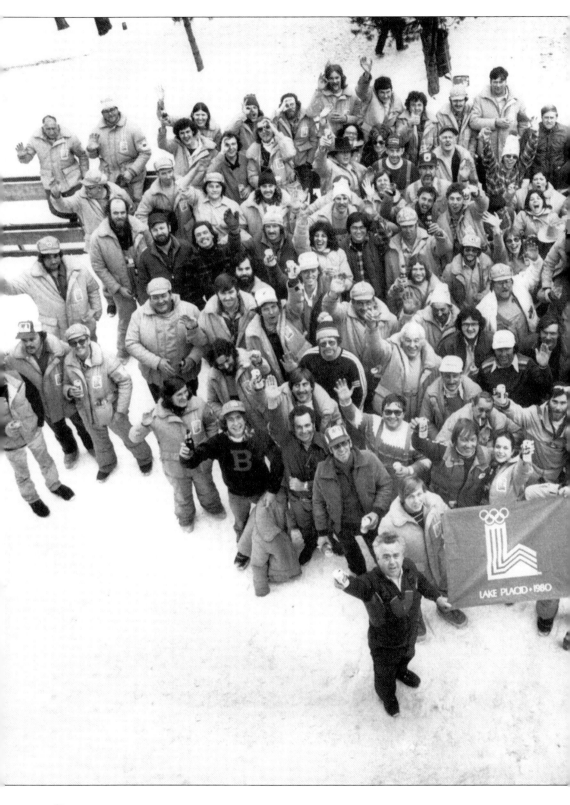

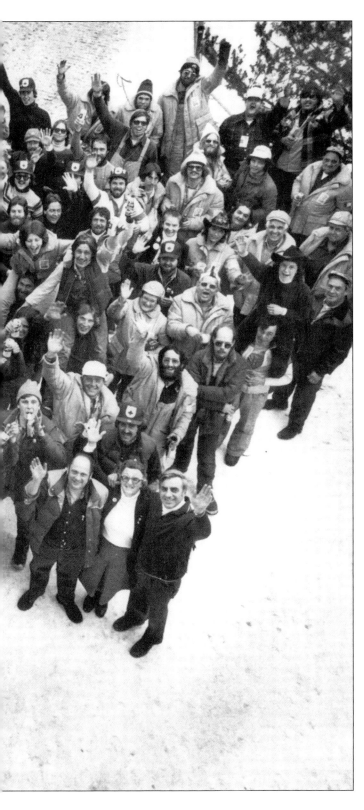

Manager Robert Paron and assistant manager Dusen "John" Plausteiner, along with the Whiteface Mountain staff and volunteers, oversaw the successful Olympic alpine events. This photograph depicts the local Whiteface Mountain staff. Snowmakers, lift attendants, groomers, and ski-school, ski-patrol, office, and administrative employees made the event a success by working around the clock before, during, and after the games. Special security passes were needed to gain entry to respective job sites. Workers also had to overcome issues posed by the crowd, media, and transportation as they commuted to and from work. (Courtesy of the Olympic Regional Development Authority.)

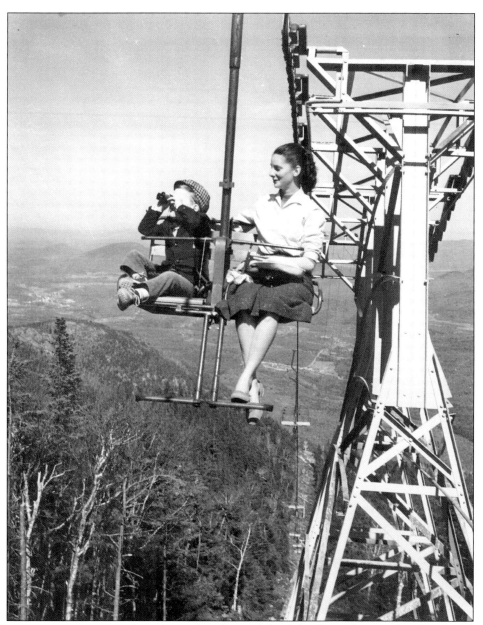

The summer tourist season brought on the advent of chairlift rides to the top of Little Whiteface for a spectacular view of the surrounding scenery, allowing income from tourist dollars to flow into the community during the after-ski season. From the vantage point of the chairlift, one overlooks the Wilmington Village, the Wilmington Notch, and the West Branch of the AuSable River. On this ride up the mountain, visitors can also examine the local flora and fauna. Upon arriving at the summit, visitors are greeted with a picturesque vista that includes surrounding lakes, streams, and mountains. The lift runs from late spring through the autumn "leaf-peeper" season. In this photograph, Joan Dreissigacker and her son John F. Dreissigacker are riding Lift Two, the Mountain Lift, as they approach the summit of Little Whiteface in 1958. Joan was active in promoting the Wilmington area. (Photograph by Van Seagraves; courtesy of the Olympic Regional Development Authority.)

Four

WILMINGTON NOTCH AND AuSABLE RIVER

The wagon road followed along the West Branch of the AuSable River through Wilmington Notch. On September 30, 1870, a wide-track stagecoach made the first passage, opening the way for further expansion. (Courtesy of Douglas A. Wolfe.)

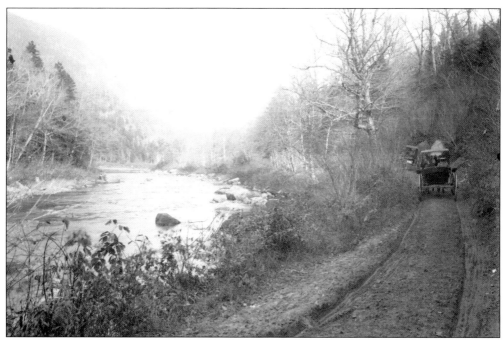

The West Branch of the AuSable River flows through Wilmington Notch, or Pass, with towering cliffs and a narrow waterway channel, making road construction difficult. A wagon track between Wilmington and North Elba was made in the 1860s, replacing the 1812 McIntyre iron-ore road through the Sentinel Range. (Courtesy of the Saranac Lake Free Library.)

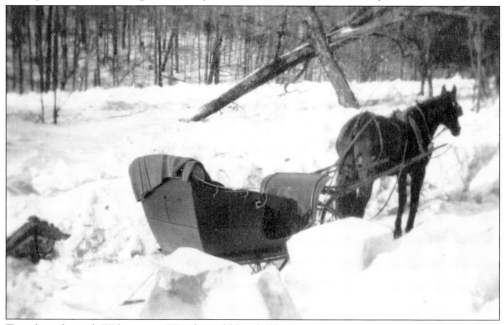

Traveling through Wilmington Notch could be challenging as steep slopes precipitated rock and snowslides, flooding from thaws, spring ice jams, and mud ruts, as seen in this c. 1900 photograph. Wind-downed trees and timber were other hazards that could be encountered. (Courtesy of Douglas A. Wolfe.)

The Wilmington Notch roadway became a New York State highway, and modernization for automobiles was done in 1916 and 1935. Road pavement and safety guardrails in hazardous areas were added for the increasing traffic usage. Advertised as "a spur on the Quebec-Miami" Highway, it became a popular attraction for motoring visitors. (Right, photograph by D.P. Church, courtesy of Lamar Bliss, St. Lawrence University Collection, postcard courtesy of the Wilmington Historical Society, Peter Yuro Collection; below, courtesy of Charles Haselton.)

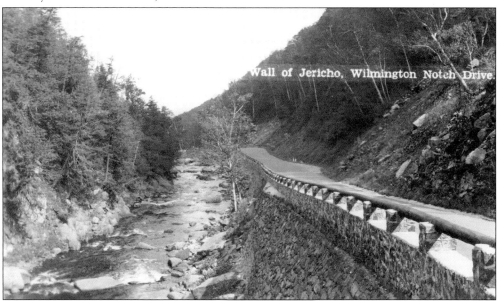

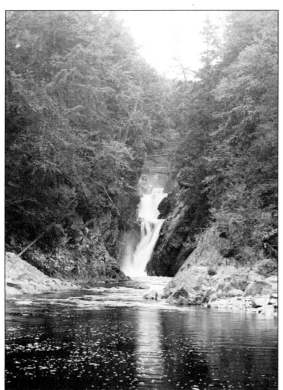

On the West Branch of the AuSable River in Wilmington Notch is the scenic natural attraction of High Falls Gorge. A series of waterfalls cascades through the gorge in a spectacular journey, and the area became a popular subject with artists and photographers by the late 1800s. In the 1902 photograph at left is the Lower Falls, after which the river continues on its path to Lake Champlain. In the 1920s photograph below is the High Falls itself, the centerpiece of the attraction. The unique geologic features were created from the 1.5-billion-year-old Adirondack Dome and carved out by wind, ice, and water. (Left, photograph by William Henry Jackson, courtesy of the Library of Congress, Prints & Photographs Division, Detroit Publishing Company Collection; below, photograph by the Wilmington Chamber of Commerce, courtesy of Mary Shea Miskovsky, Smith Family Collection.)

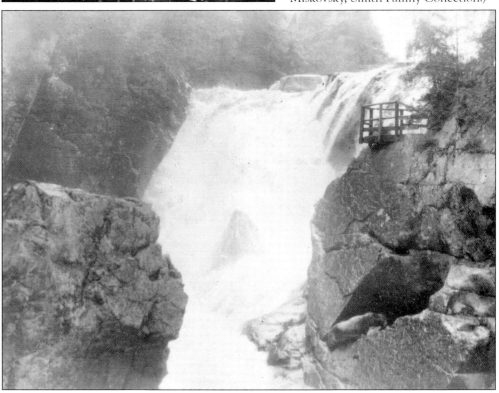

The entrance to High Falls Gorge, seen right in September 1905, shows a portion of the many well-placed bridges and walkways. The experience allowed visitors accessible views of the wonders of the many potholes, cataracts, strata, and fissures, while also permitting them to hear the roar and feel the spray of the falls. In the early-1900s photograph below, a young girl is able to stand above the AuSable River, directly in front of the High Falls. According to the *Plattsburgh Press Republican* on June 21, 1992, High Falls Gorge first opened as an attraction around 1890 but was intermittently closed to the public up until the end of World War II, when it became inactive. It was revived in 1961 and has operated continuously since then. (Right, courtesy of Carol Latone, Winch Collection; below, courtesy of Saranac Lake Free Library.)

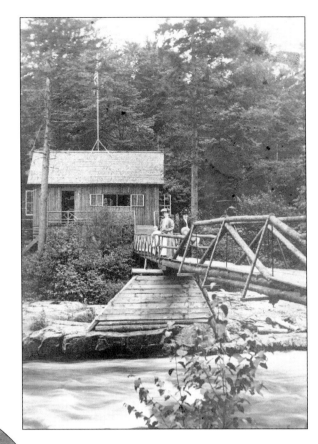

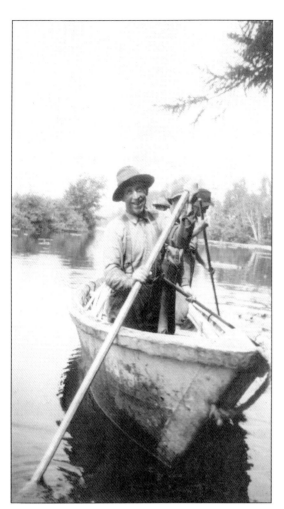

Quiet waters on the river were conducive to both industrial and recreational uses, as seen in the c. 1920 photograph at left of log drivers navigating their boat. Below, the early settlers constructed a wooden, earth-filled dam for water-powered sawmills and gristmills. This remained in use for over 100 years but required frequent repair (Both, courtesy of Suzanne Underwood Field.)

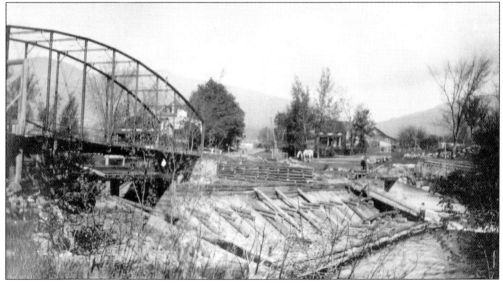

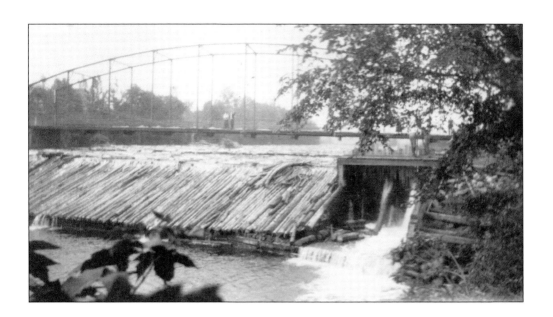

Wooden cribbing filled with dirt and rock riprap was covered with sloping wooden planks to prevent a "plunge pool" excavation (the force of falling water moving or excavating the soil and stone) and undermining of the crib dam. Gated sluices allowed the water flow to be controlled for industrial uses, as demonstrated in the 1920s picture above. The crib structure was breached on several occasions, as seen in the 1920s image below, and the final failure occurred in March 1936, causing concern for tourism and businesses. High above the water, a unique iron parabolic truss bridge was installed in 1897 to replace the original wood trestle structure and was in use until 1934, when it was replaced with the concrete arched bridge. (Both, courtesy of Suzanne Underwood Field.)

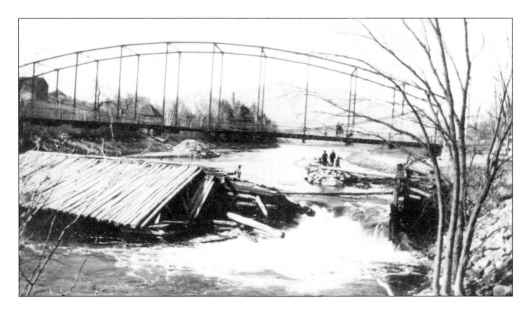

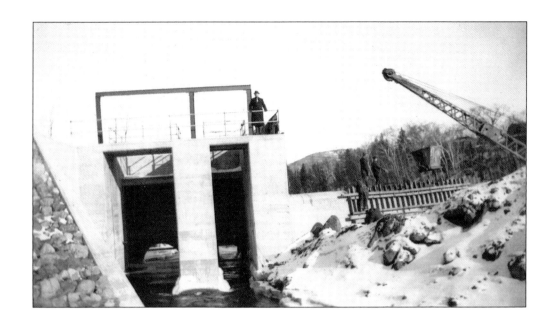

Local politicians, including supervisor James C. Wolfe, and area businessmen promoted the importance of the dam and lake to federal administrators and received Works Progress Administration funding to build a public park area, which included a new dam. Old dam debris cleanup and construction started in 1937. The bulkhead gate control side was started first with a round penstock outlet included for future hydroelectric development, pictured above. Below, a riverbed channel was excavated to direct the water flow away from the immediate construction area. (Both, courtesy of Douglas A. Wolfe.)

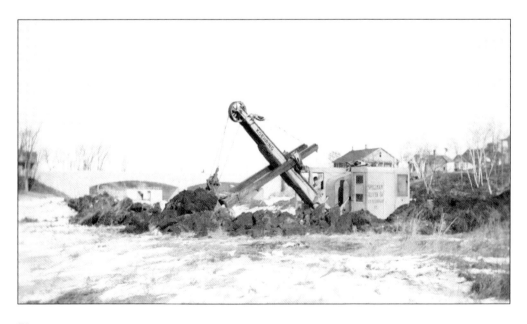

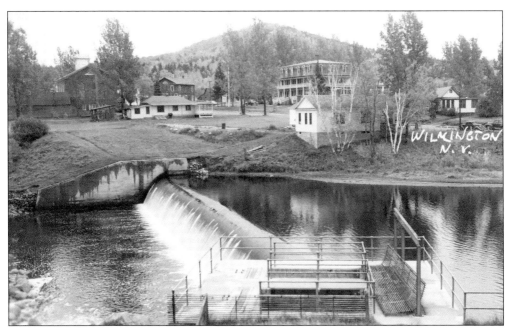

The concrete dam, completed in 1938, restored the recreational assets of the town. Its first real test was high water from the September 1938 New England hurricane. The overall width was 260 feet, and the spillway top elevation was 986 feet above sea level. The watershed area is 142 square miles. (Courtesy of Charles Haselton.)

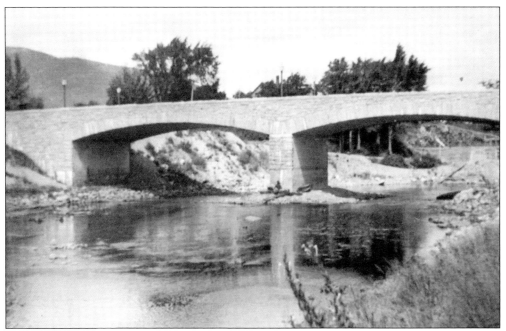

The third bridge over the river was a concrete structure with graceful arches and a granite exterior, constructed in 1934. It was designed to handle the increasing automobile and truck traffic and to complement the Whiteface Mountain Veterans Memorial Highway. (Courtesy of the Connor and Wolfe families.)

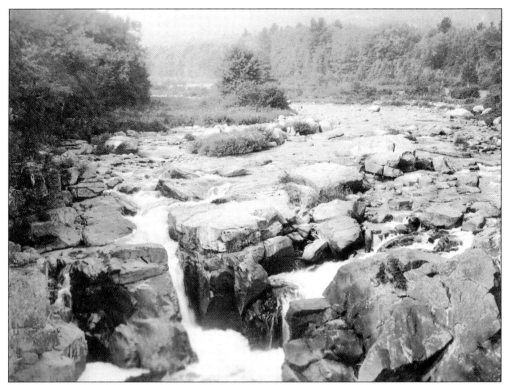

This upstream view of the West Branch of the AuSable River from the Flume Bridge is a favorite scene for artists and photographers. With the varied conditions of the river and the changing of the seasons on the Whiteface Range, many have taken time to record their experience on film and canvas. (Photograph by the Wilmington Chamber of Commerce; courtesy of Mary Shea Miskovsky, Smith Family Collection.)

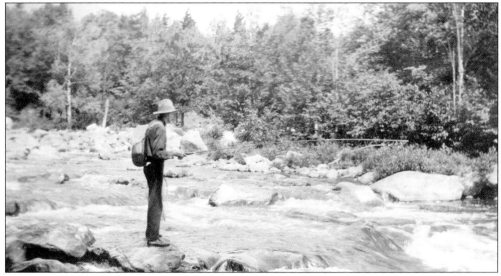

As demonstrated in this 1920s photograph, the West Branch of the AuSable River has long been a favorite river with anglers using both flies and bait. The old hotels all had native trout on their menus. (Courtesy of Suzanne Underwood Field.)

The steep slopes of the mountains near Wilmington were logged extensively for pulpwood to supply the J&J Rogers Company Mill in AuSable Forks. To safely move wood to the river, log slips (water-filled wooden troughs) were used, as seen here in 1904. Logs dropped into the river or were piled on the ice until spring's high water arrived. (Courtesy of Carol Latone, Winch Collection.)

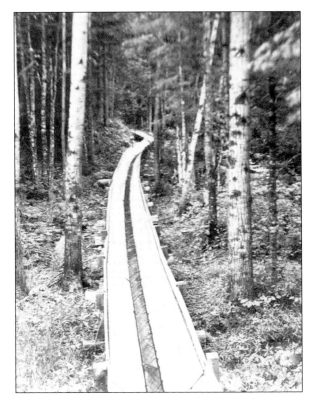

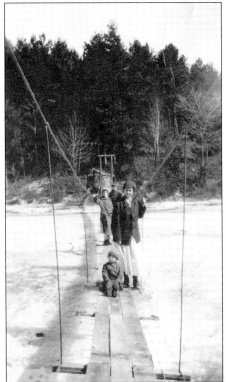

Mary Pelkey Stephenson, her young son Lawrence, Minnie Pelkey Stephenson, and William Stephenson are crossing the West Branch of the AuSable River in the hamlet of Haselton around 1917. The suspension footbridge connected the two family farms. When the river was low enough and free of ice, they would cross with horse and wagon upstream at the fordway. (Courtesy of Celia Stephenson.)

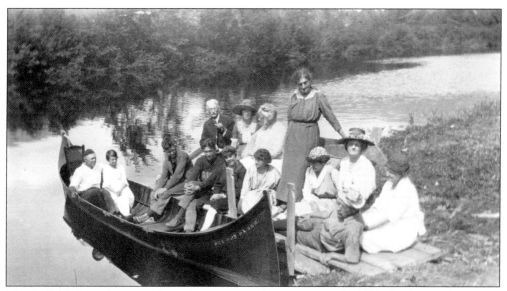

The AuSable River became a focus for tourism and recreation in the 1920s. In the wooden canoe are Fred Adams and Margaret McPherson Middleton with the rest of the Adams and Brown families relaxing nearby. It became popular to name boats, often with Native American names, and this canoe was called *Gha Won Da See*. (Courtesy of Suzanne Underwood Field.)

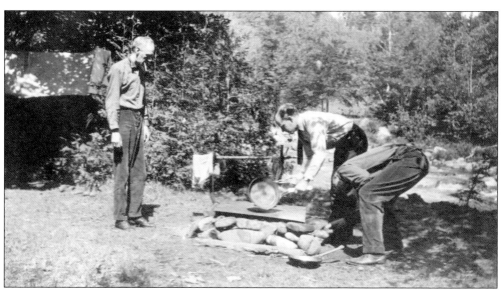

Outdoor camping began to take root in the area starting in the early 1900s. Setting up camp on the AuSable River about 1920, these three men are readying to prepare a meal over a campfire. (Courtesy of Suzanne Underwood Field.)

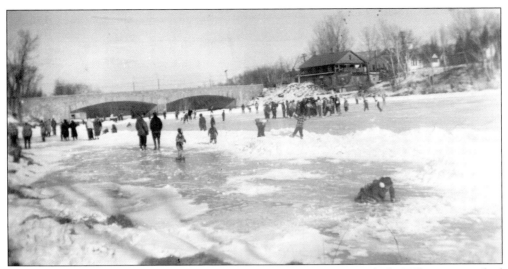

This 1952 photograph shows recreational ice skaters on Lake Everest with the Wilmington arched bridge in the background. For a number of years, the Wilmington Fish, Game and Sports Club also sponsored the New York State Outdoor Speed Skating Championships, drawing competitors from throughout the Northeast and Canada. (Courtesy of the Wilmington Historical Society, Ruth Boyer Collection.)

Organized in 1920, the Owaissa Club was built at the site of the current town beach and maintained as a youth recreation center. A small fee admitted residents and guests to membership. Equipment included rowboats, canoes, a motion picture machine, a player piano, a phonograph, indoor and outside fireplaces, a kitchen, and a reading room. (Photograph by the Wilmington Chamber of Commerce; courtesy of Mary Shea Miskovsky, Smith Family Collection.)

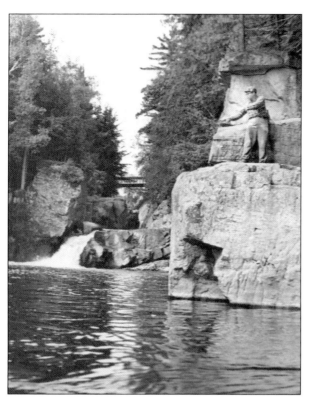

Francis Betters, seen here in the 1960s, fished the Flume Pool many times throughout his life. He started fishing the AuSable River as a young boy and made a career out of his knowledge of the river and his skills as a fly fisherman. (Courtesy of Peggy Betters.)

Lawrence Stephenson poses with his catch of trout on the first day of fishing season in 1959. This fishing hole is near the Whiteface Mountain Ski Center. Lawrence was an avid hunter and fisherman all his life. (Courtesy of Guy Stephenson Jr.)

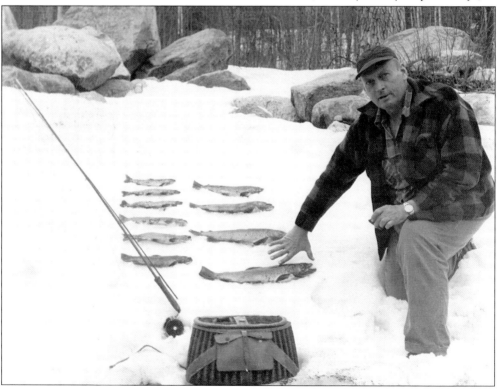

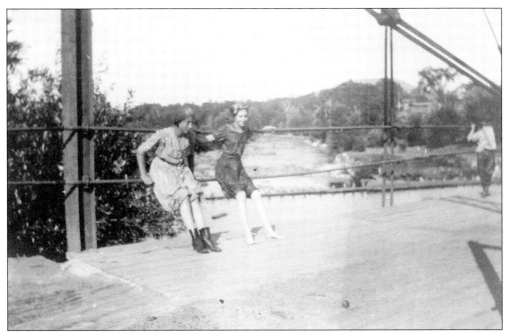

Two women are resting on the parabolic truss bridge after taking a swim around 1915. The centrally located town bridge has always been a hub for community recreation and events, including fishing, boating, and swimming. The West Branch of the AuSable River offers several great swimming holes. (Courtesy of the Wilmington Town Historian, Lucille Obst Collection.)

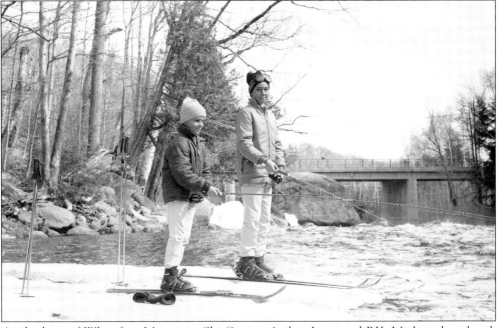

At the base of Whiteface Mountain Ski Center, Arthur Lussi and P.K. Mader take a break from skiing to enjoy the beginning of fishing season, angling for trout on April 8, 1969. With Wilmington a four-season resort town, the "seasons" often overlap. (Courtesy of the Olympic Regional Development Authority.)

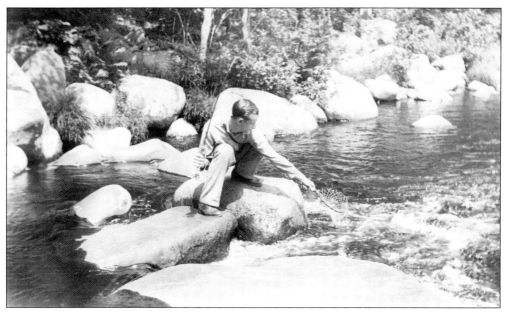

Local resident Reginald Wolfe demonstrates netting a fish while on slippery rocks in flowing water. He became an area game warden and served for three decades. (Courtesy of Douglas A. Wolfe.)

Named after one of Wilmington's most noted entrepreneurs, Frank Everest, "the pond" was officially named Everest Lake on July 21, 1921, complete with a celebration. The lake, created by the dam on the river, is used for boating, swimming, fishing, skating, and bird-watching. (Courtesy of Suzanne Underwood Field.)

Five

VISITOR
ACCOMMODATIONS

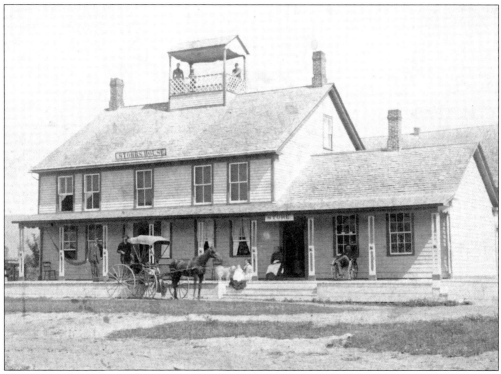

The Storrs House, located at Route 86 and Haselton Road, was built by pioneer Reuben Sanford around 1810. In this post–Civil War view, note the widow's walk on the roof, a feature usually found on New England homes. The house was used as an inn, a stage stop, and a store. According to local lore, it was also a stop on the Underground Railroad. (Courtesy of Mary Preston.)

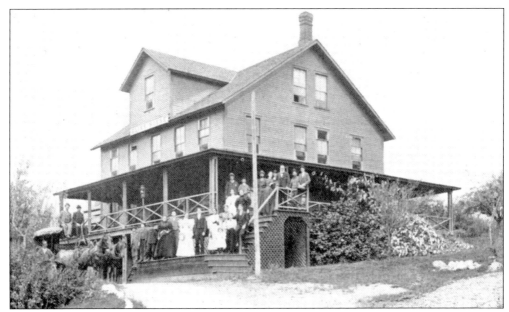

The Bliss House, seen in this view from the late 19th-century hotel brochure, was a popular stage stop. Located on the west side of the bridge, it advertised fresh food, good water, telephone and telegraph connection, a first-class livery, saddle horses, fine baseball grounds, and a tennis court. It also offered a direct bridle path to the top of Whiteface Mountain. (Courtesy of the Wilmington Historical Society.)

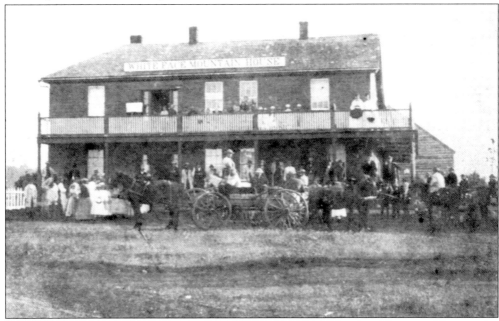

Taken from a c. 1870 stereoscopic view, this photograph of the Whiteface Mountain House at the corner of Springfield Road and Route 86 lists George Weston as proprietor. In an 1871 descriptive guide to the Adirondacks, the Whiteface Mountain House was featured, touting the beauty of the area, offering "boats on the river," and "guides, carriages, and good saddle horses for ascending the mountain." (Photograph by H.S. Tousley; courtesy of Robert Peters.)

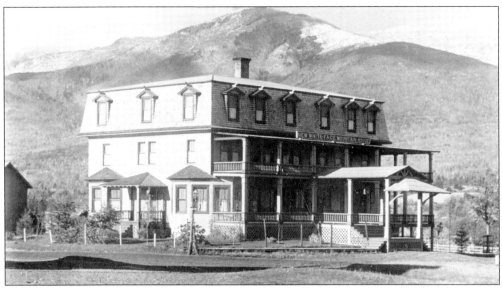

The view above shows the New Whiteface Mountain House in the early 1900s. According to a 1916 travel guide, this "popular house," now with Frank E. Everst as proprietor, offered "large piazzas, light and airy rooms, hammocks, swings, and sand gardens for children." Accommodations for 75 people were available, and terms were $10 to $14 per week. In its peak years, the Whiteface Mountain House employed 30 persons and served 600 meals on a busy summer Sunday. In 1920, owner Frank Everest financed the construction of a generator at the dam to electrify the hotel to bring it up to the standards and expectations of its guests. The 1953 photograph below shows the Whiteface Mountain House at the end of its glory days before it was eventually demolished. (Above, courtesy of the Wilmington Town Historian; below, courtesy of the Essex County Clerk.)

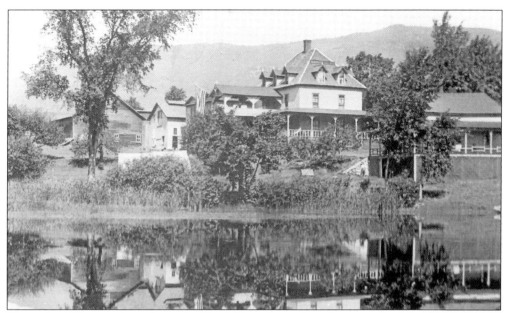

The early-1900s view above shows the Hotel Olney, located on the west side of the AuSable River. It was first owned by Civil War veteran Edwin Olney, who established his hotel business around 1870. Edwin's son Oscar Olney took over the business and was proprietor well into the 20th century. The hotel had lawn tennis and croquet grounds as well as a piano and organ provided for guests. Guest cottages were also an option. As new owners came along, the hotel was variously named the Whiteface Club, the Homestead, the Wilmington Inn, the Cloudspin Inn, the Falcon's Nest, and lastly the Wilmington Inn. The Wilmington Inn is shown below in 1951. It was destroyed by fire in the 1980s. (Above, courtesy of the Wilmington Town Historian, Lucille Obst collection; below, courtesy of the Essex County Clerk.)

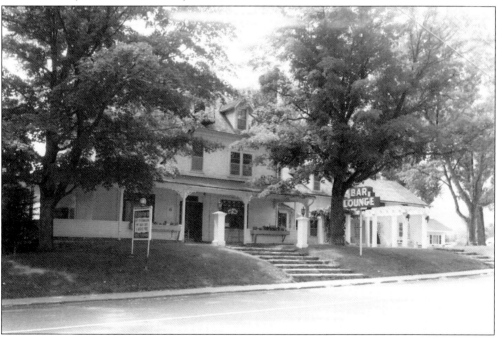

In this early-1900s mountain guide camp photograph, note the carved slab wood sign hanging next to the porch roof, "Hotel Winch." A successful hunt yielded a good-sized buck. Asher Winch, along with his father Cassius, both Adirondack hunting and fishing guides, operated three guide camps on Owens, Winch, and Copperas Ponds. (Courtesy of Carol Latone, Winch Collection.)

Fred Winslow Adams built an early camp called Hunky Dory on the AuSable River's east side in 1911, seen in the background of this c. 1915 photograph. In the foreground is the Bluebird Camp, which Ida Gardner Greason (later Underwood) had constructed in 1915. Oscar Olney, proprietor of the Olney Hotel, was the contractor for the Bluebird Camp and also fabricated rustic furniture for it. (Courtesy of Suzanne Underwood Field.)

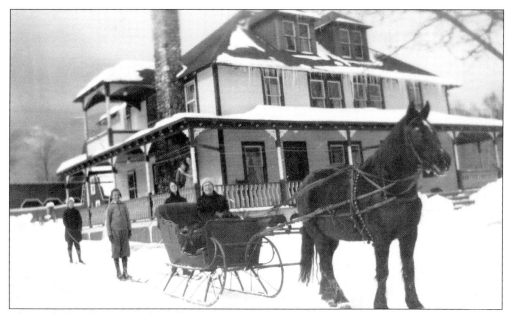

This early farmhouse, Maple Hill (now called Bonnie View), was acquired by James C. Wolfe. He and wife Florence expanded it for their large family, foster children, and various boarders. Several bungalows were constructed for visitors. A Scottish guest once commented on the "bonnie view," hence the current name. Guests could experience a working farm or take part in outdoor recreational activities. (Courtesy of Douglas A. Wolfe.)

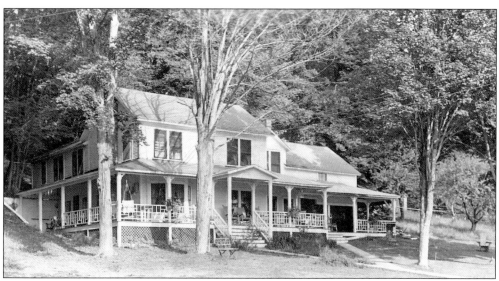

With the growth in tourism, local residents were able to increase their income by boarding guests. The Whiteface Farm, now the Wilkommenhof on Route 86 toward Lake Placid, has been serving tourists since the 1920s, when this photograph was taken. It touted electric lights, modern plumbing and baths, and garages. It also offered home cooking featuring the farm's own vegetables, milk, cream, butter, and eggs. (Courtesy of Gerald Bruce.)

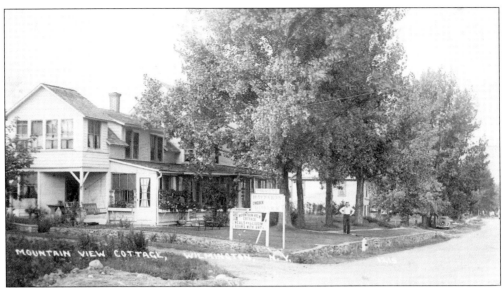

This 1920s real-photo postcard of Ed Maynard's Mountain View Cottage and Annex on Route 86 reveals multiple additions to the home. The sign welcomes tourists and advertises meals and lodging. Guest rates were $3.50 and up. The proprietors could arrange automobile transportation to and from the Lake Placid or AuSable Forks railroad stations, and competent guides were furnished for hunting, fishing, and exploring the Whiteface Mountain trails. (Courtesy of Cecile Maynard Dale.)

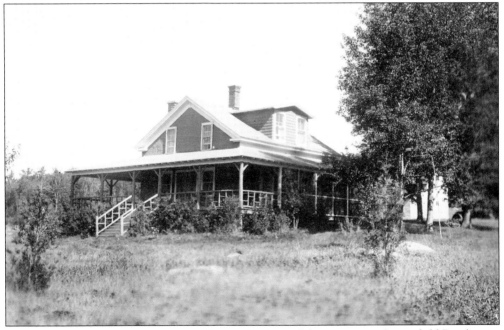

Originally built as a farmhouse around 1840, the Gun Club Cottage on Springfield Road was a seasonal rental at the time of this 1920s image. Owner George "Adirondack" Smith of Springfield, Massachusetts, had purchased it years earlier with 16 friends to use as a hunting and fishing cottage. Eventually, George became the sole owner. (Photograph by the Wilmington Chamber of Commerce; courtesy of Mary Shea Miskovsky, Smith Family Collection.)

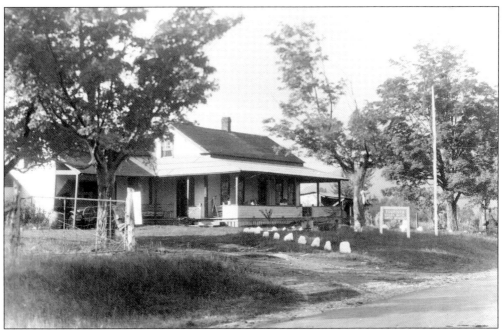

Originally owned by Thurlow Bell, Ox Yoke Farm on the Jay Road is seen in this 1920s photograph. It advertised rooms with a bath, supper, and breakfast. It also suggests early recreational camping with its announcement of a white birch campground on its premises with firewood and water available. (Photograph by the Wilmington Chamber of Commerce; courtesy of Mary Shea Miskovsky, Smith Family Collection.)

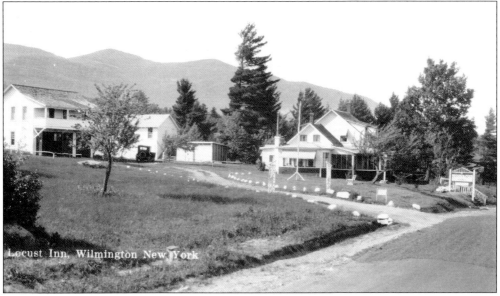

At the time of this 1920s image, the Locust Inn on Lake Placid Road, then owned and managed by Henry and Anna LaMoy, offered rooms and meals. A June 11, 1937, *Lake Placid News* advertisement urged readers to "drive down for the dinner that has made Locust Inn famous for 14 seasons." (Photograph by D.P. Church; courtesy of Lamar Bliss, St. Lawrence University Collection; postcard courtesy of the Wilmington Historical Society, Peter Yuro Collection.)

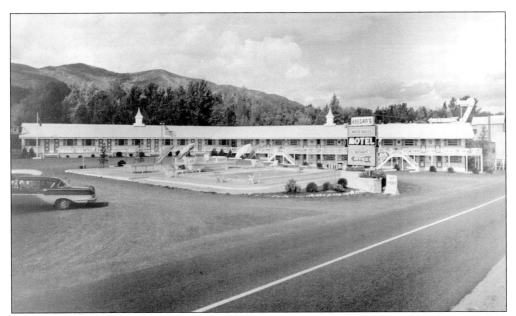

In the early 1950s, with Santa's Workshop as an added summer attraction and family automobile vacations on the rise, many motels were built in Wilmington. The 37-room White Brook Motel on Route 86, seen in this 1950s photograph, was constructed and operated by entrepreneur Thomas Keegan. A restaurant, swimming pool, and free television were added amenities. The motel was destroyed by fire in 1986. (Courtesy of Dennis Keegan.)

In the 1920s, the Blue Bowl Tea Room was located on Lake Placid Road at Flume Falls. It was operated by Katherine Adams of Philadelphia as a popular summer restaurant catering to parties ranging from small teas to large dinners and informal dances. Later owners renamed it Kelly's, then the Hungry Trout. (Photograph by the Wilmington Chamber of Commerce; courtesy of Mary Shea Miskovsky, Smith Family Collection.)

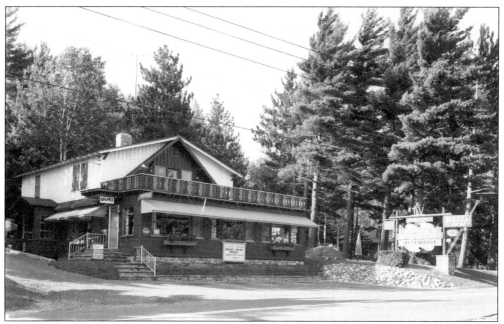

This 1960 photograph shows the Romang Motor Court and Restaurant, located on Lake Placid Road. From the 1940s to the 1960s, the complex, owned and operated by Glen and Helen Bacon, was known collectively as Camp Romang after Helen's father, George Romang. Since that time, it has been known as the Viking Restaurant and later as the Wilderness Inn II. (Courtesy of the Essex County Clerk.)

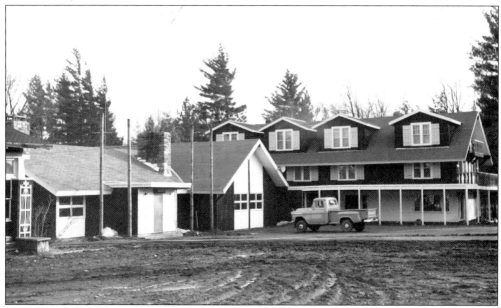

Steinhoff's Sportsman's Inn is shown in this photograph taken April 8, 1959. Carl H. Steinhoff opened his restaurant in the 1940s on the West Branch of the AuSable River on Lake Placid Road. A German immigrant and skilled hunter and fisherman, Carl was a master chef. His sense of humor and lively personality made Steinhoff's a popular gathering place. Carl died in 1971. (Courtesy of the Essex County Clerk.)

Six

SANTA'S WORKSHOP

Santa's Workshop, depicted as "the Enchanted Village of the Adirondacks" in this early poster, was the first of its kind in postwar America. It was located one mile above the town of Wilmington on the scenic Whiteface Mountain Veterans Memorial Highway. The park opened on July 1, 1949, and quickly became a vacation destination for families eager to visit Santa in his summer home. (Courtesy of Santa's Workshop Incorporated.)

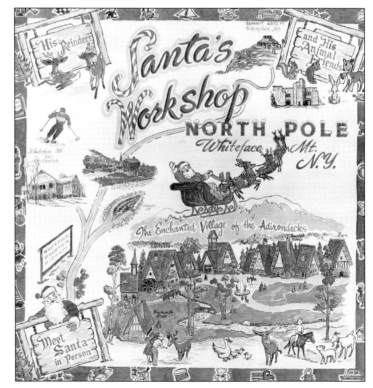

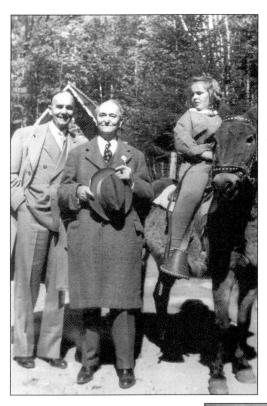

Three generations of the Reiss family—Julian; his father, Jacob; and daughter Patti—were all instrumental in the founding of Santa's Workshop. The idea for the theme park was inspired by a "Baby Bear" story Julian told Patti during the holiday season of 1946. Jacob, a wealthy New York City businessman, was easily persuaded to provide capital for the venture. (Courtesy of Santa's Workshop Incorporated.)

Santa converses with his "Three Wise Men," from left to right, Arto Monaco, Julian Reiss, and Harold Fortune. Together, they brought to life the concept of Santa's Workshop. Former Disney artist Arto Monaco, from nearby Upper Jay, designed the village. Harold Fortune, a log cabin builder from Lake Placid, provided the land and oversaw the construction of the buildings. Santa and Reiss provided inspiration and direction. (Courtesy of Santa's Workshop Incorporated.)

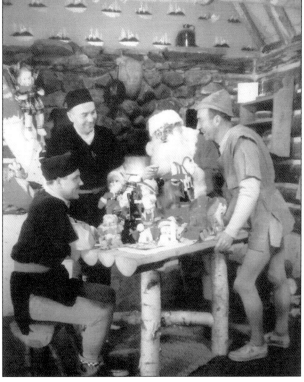

The Santa's Workshop parking lot is seen here around 1950. The 1950s advertising slogan "See the USA in your Chevrolet" found families hitting the highways in search of fun and adventure. Every day, hundreds of vehicles passed through Wilmington on their way to Santa's Workshop. On Labor Day 1951, an estimated 14,000 people visited the theme park, and the resulting traffic jam measured four miles long. (Courtesy of Santa's Workshop Incorporated.)

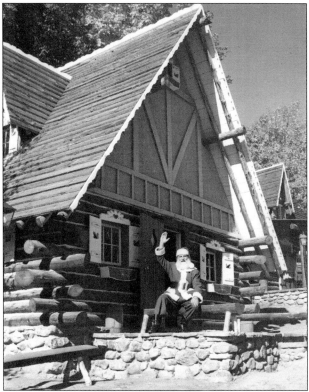

Eager to welcome summer visitors, Santa waves from a log bench in front of his charming home. Keeping with the storybook woodland theme, all of the buildings were constructed of rustic logs and accented with colorful, Bavarian-style facades. Santa's house sported yellow stucco topped off with a bright blue roof. Red trim, green window boxes, white shutters, and gingerbread added to the enchantment. (Courtesy of Santa's Workshop Incorporated.)

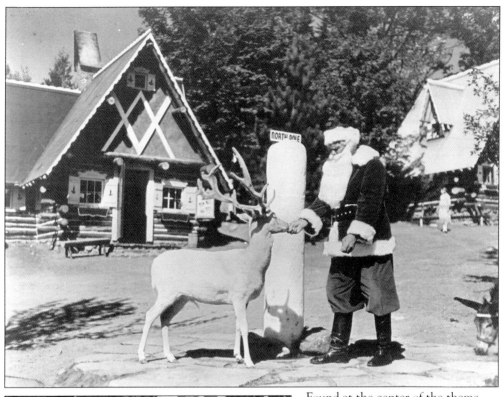

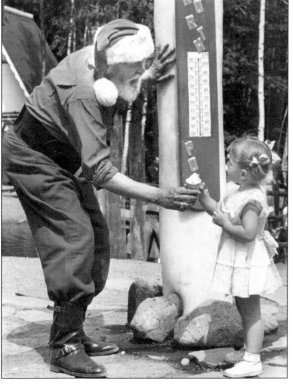

Found at the center of the theme park, the legendary North Pole quickly became an iconic symbol for family fun on Whiteface Mountain. This picture, taken in 1949, shows Santa with one of the many white fallow deer that roamed freely about the grounds. The image was among the first to be mass produced on early promotional literature and souvenir merchandise. (Courtesy of Santa's Workshop Incorporated.)

Thanks to the magic of modern refrigeration, the North Pole remained covered in a thick layer of icy snow, even during the summer's hottest days. In reality, the frosty pole, with its four- to seven-inch frozen coating, was a metal cylinder mounted on a stone base that hid the inner workings. The thermometer proved to children that it was indeed the *real* North Pole. (Courtesy of Santa's Workshop Incorporated.)

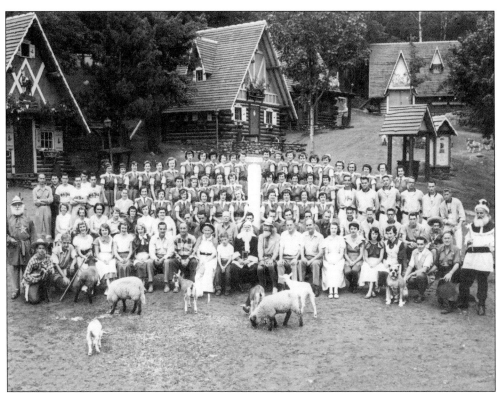

This early-1950s staff photograph shows the crew who made Santa's Workshop on Whiteface Mountain a booming success. Many of the storybook characters, entertainers, gnomes, and elves were local residents. Those who came from far away boarded at the Courtney House in the Wilmington village. Workers were picked up every morning in a 1949 Chevrolet truck and brought up the mountain to work their magic. (Courtesy of Santa's Workshop Incorporated.)

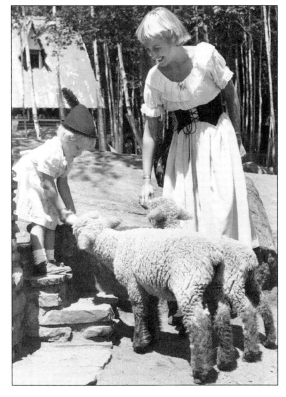

Since the beginning, the theme park was known, first and foremost, as Santa's summer residence. Its secondary appeal was its storybook characters and their animal friends. Santa's Workshop was the nation's first petting zoo, with over 200 tame deer, goats, sheep, rabbits, ducks, and geese. Here, Bo Peep and a helpful little friend take time out to feed her thirsty lambs a bottle of milk. (Courtesy of Santa's Workshop Incorporated.)

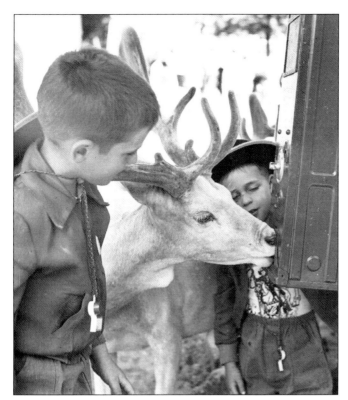

Two boys watch as a white fallow deer attempts to get a free meal from the coin-operated grain dispenser. The mild-mannered species originated in Europe and adjusted well to life at Santa's Workshop. They roamed freely and were friendly to anyone offering them a snack. Santa's famous team consists not of fallow deer, but rather of Alaskan reindeer that came to the park in 1953. (Courtesy of Santa's Workshop Incorporated.)

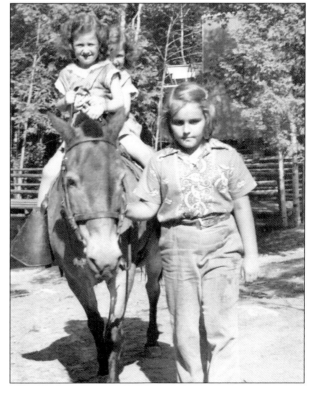

Interaction with live animals played a big role in the attraction of Santa's Workshop. Youngsters had the exciting opportunity to experience the adventure of pony rides in a safe environment. Here, Patti Reiss is shown leading two little girls on a ride through the park. Storybook characters Tom Sawyer and Huckleberry Finn also gave pony rides to young visitors. (Courtesy of Santa's Workshop Incorporated.)

Famous singing star Kate Smith owned an Adirondack great camp in nearby Lake Placid, so she visited Santa's Workshop often. The Adirondack Mountains inspired her to write the lyrics for the tune "When the Moon Comes Over the Mountain." In 1931, the melody became her official radio—and later television—theme song. Today, Kate is most remembered for her stirring rendition of "God Bless America." (Courtesy of Santa's Workshop Incorporated.)

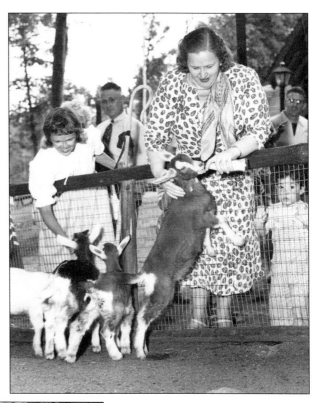

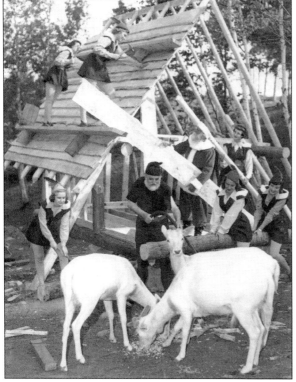

Since live entertainment was an important aspect of Santa's Workshop, there needed to be a special place where daily performances could be held. Here, Santa works together with his elves and gnomes to build the North Pole Show House—the smallest of the buildings in the park. It was situated in the area of the animal nursery and blacksmith shop. (Courtesy of Santa's Workshop Incorporated.)

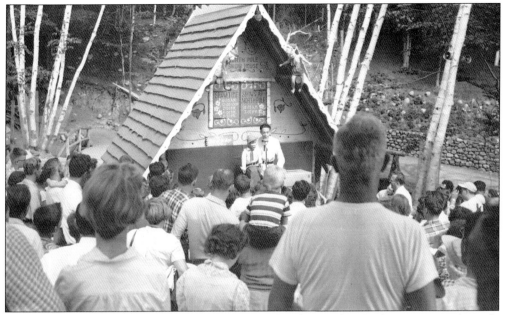

Santa's ventriloquist is seen here entertaining a crowd at the North Pole Show House in the early 1950s. This is where five daily performances took place, including a magic show and a *Punch and Judy*–style puppet show. In the early 1970s the Mother Goose Guild was formed. The Yule Tide Theater, in a natural outdoor amphitheater setting, became the site of daily performances. (Courtesy of Santa's Workshop Incorporated.)

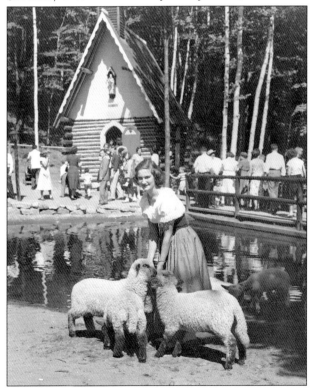

Keeping Christ in Christmas was important to Julian Reiss, who was a devout Catholic. St. Nicholas Chapel, seen in the background, invited guests to honor the birth of Jesus as they gazed upon a nativity scene while listening to a recorded inspirational message. In keeping with the true meaning of Christmas, a live Nativity pageant was added to the daily roster of shows in the mid-1950s. (Courtesy of Santa's Workshop Incorporated.)

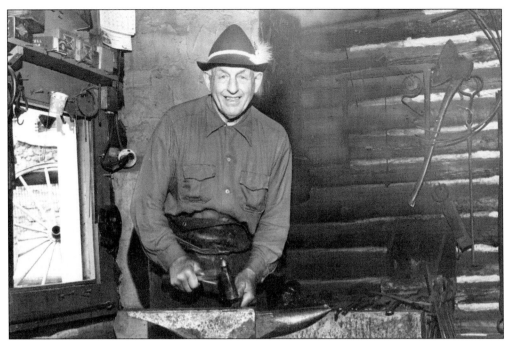

The Blacksmith Shop, with its bright red and blue color scheme, was a real working forge where the smithy and his elf assistants demonstrated the skill of hand-forging iron. Seen here, Charlie Soulia from Peru, New York, was Santa's blacksmith from the mid-1960s through the mid-1970s. It was here that a myriad of handcrafted souvenir items, like horseshoes and fireplace tools, were produced. (Courtesy of Santa's Workshop Incorporated.)

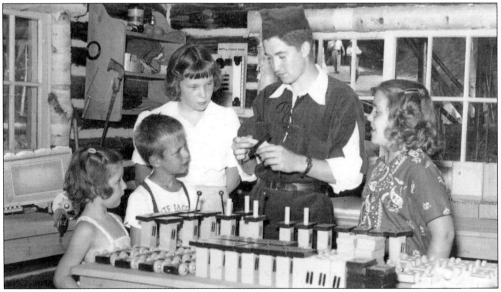

What would Christmas be like without toys? Here, Patti Reiss and some other children look on as an elf assembles wooden trains designed by Santa's chief artist, Arto Monaco. The Waterwheel Toyshop was just one of the attractions where visitors could see elves and gnomes at work. Other craft demonstrations included glassblowing, pottery, candle making, silver work, plastic carving, wreath making, and leather tooling. (Courtesy of Santa's Workshop Incorporated.)

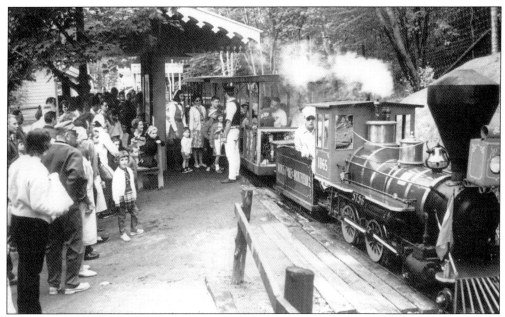

When amusement rides were introduced to Santa's Workshop, the average staying time increased from 45 minutes to five hours. Since the beginning, the Candy Cane Express, a scaled model train with coal-fired steam engine, brought guests through Santa's enchanted forest and around the upper park. In 1965, the Reindeer Carousel was added, followed by several other rides, including the Christmas Tree Ride and Kiddie Bobsled. (Courtesy of Santa's Workshop Incorporated.)

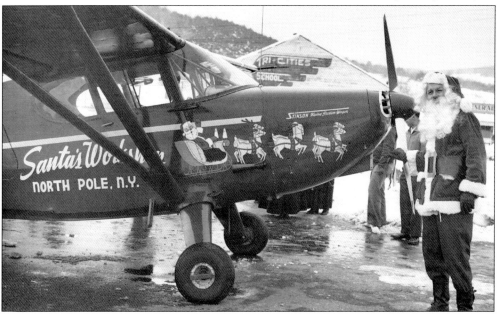

Julian Reiss, seeing delight in the faces of young visitors, turned his thoughts to those less fortunate. A wishing well fund, hosted by Elmer the Elf, collected coin donations to purchase toys for the underprivileged. Santa's Operation Toylift got off the ground December 9, 1949, when Reiss, seen here with his personal aircraft, flew a load of toys to an Ogdensburg, New York, orphanage. (Courtesy of Santa's Workshop Incorporated.)

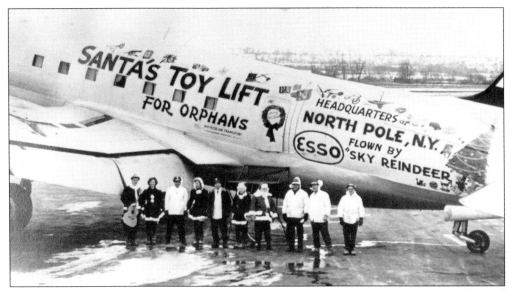

As news of Santa's Operation Toylift spread, volunteer organizations and toy manufacturers donated to the cause. In 1952, ESSO Standard Oil Company provided a DC-4 freight liner to help deliver toys to thousands of underprivileged children across America. The plane, called the *Silver Sleigh*, landed in 34 major cities across 18 states and Canada. To this day, Santa's Workshop continues to collect donations for those less fortunate. (Courtesy of Santa's Workshop Incorporated.)

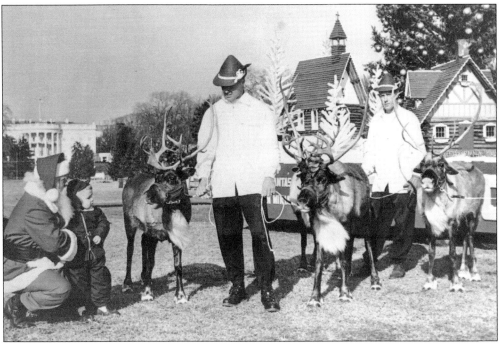

In 1955, Santa's Operation Toylift Fund was approved as a national tax-exempt charity. That year, and again in 1956, Santa's Workshop took part in President Eisenhower's Pageant of Peace in Washington, DC. This photograph, with the White House in the background, shows Santa and his helpers next to the national Christmas tree. The miniature buildings were replicas of St. Nick's Chapel and Santa's House. (Courtesy of Santa's Workshop Incorporated.)

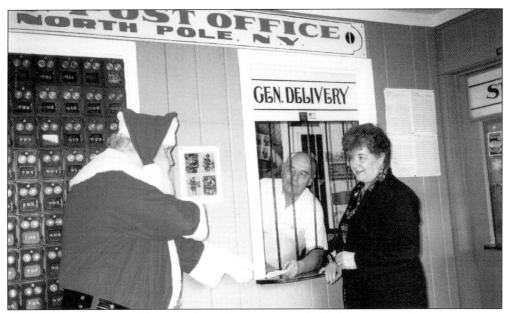

Santa's North Pole Post Office has always been a bustling hub of activity, sending and receiving mail. On December 16, 1953, the US Post Office Department recognized North Pole, New York, with their very own cancellation stamp, and in 1963, the zip code 12946 was assigned. In this photograph, park manager Bob Reiss acts as postmaster, while Santa and Wilmington postmaster Joanne Zaumetzer look on. (Courtesy of Santa's Workshop Incorporated.)

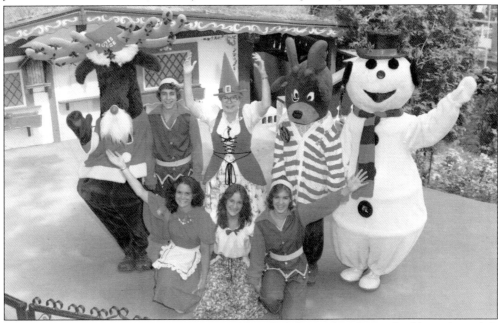

During the early 1970s, a performance ensemble called the Mother Goose Guild was formed. It was centered around Margo Hess, seen here as Mother Goose. Margo was a professional puppet master and storyteller, and her magician husband, Larry, was Santa's wizard of the North. In 1973, the Hesses hosted the first Yuletide Family Weekend at the Wilmington Holiday Lodge. The program continues to this day. (Courtesy of Santa's Workshop Incorporated.)

Seven

COMMUNITY

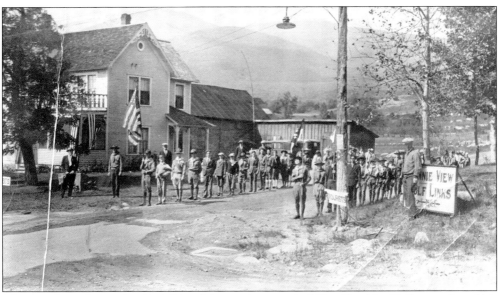

This parade on September 11, 1929, celebrates the arrival of Gov. Franklin D. Roosevelt and his anticipated announcement of the soon-to-be Whiteface motor road. Changes are already evident in the tourists sign on the light pole and the new Bonnie View Golf Links sign. (Courtesy of the Wilmington Town Historian, Jeanette Sibalski Collection.)

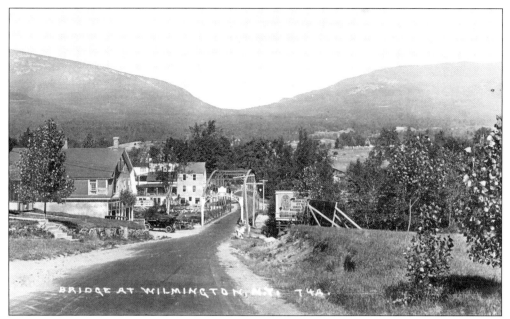

In this photograph taken of Wilmington's center around 1920, a billboard promoting area tourism can be seen. It advertises the 1000 Animals Park in AuSable Chasm and Lake Placid. The Hayes Cemetery on Bonnie View Road is visible in the upper right. (Courtesy of the Marshall family.)

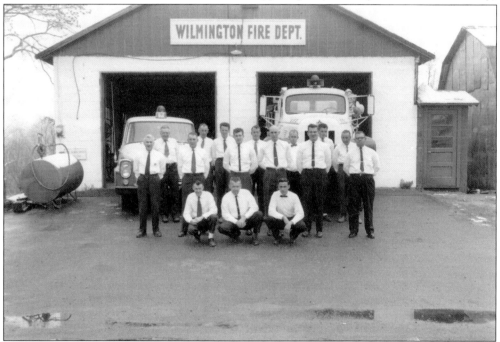

The Wilmington Fire Company, organized in 1921, received town board approval in 1923. The 1962 fire department includes, from left to right, (first row) Bruce Hare, Rodney Ritchie, and Francis Kane; (second row) Ellison Urban, James O'Mara, Anson Washburn, Dietrich Lee Hinds, Fritz Heider, Ed Joyal, Eugene Betters, Leo Cooper, Francis Lawrence, Rev. Alan Smith, James Rowe, Robert Preston Sr., and Carol Yard. (Courtesy of the Wilmington Fire Department.)

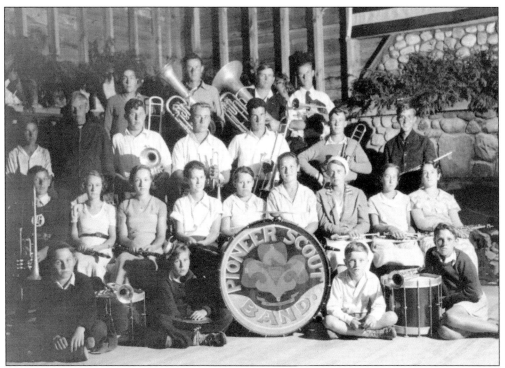

Girl Scouts and Boy Scouts assembled and practiced their musical skills in the Pioneer Scout Band, shown here in the summer of 1930. The group participated in dances, parties, parades, and special occasions from their base at the Owaissa Club and provided socializing opportunities for youths. (Courtesy of Douglas A. Wolfe.)

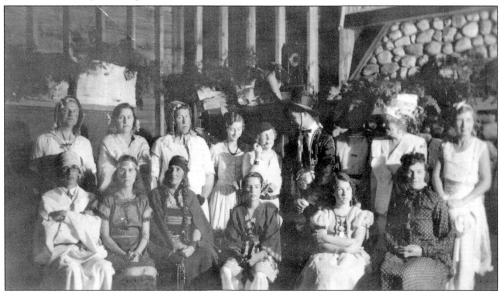

The Owaissa Club celebrated its annual anniversary with a costume party, and prizes were given for best costumes. In 1934, Mehitable Marshall won for being an Indian squaw and Rob Smith won for being a very tall man. This photograph is from a costume party around 1933. (Courtesy of the Wilmington Town Historian, Helen Warren Collection.)

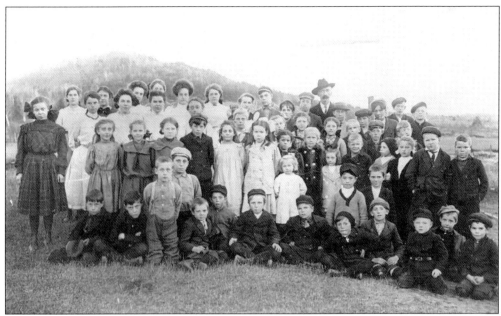

There were a total of eight single-room schools in Wilmington in 1850. They included the Upper Forge School, the Kilburn School, the Village School, the Haselton School, the Hardy School, the Hickok School, the Markhamville School, and the Lawrence/Winch School. In the 1909 photograph above, Wilmington Village teacher Frank Shumway is surrounded by his students. In 1911, a new Wilmington Village two-room schoolhouse was built on the site of the previous one-room structure. The c. 1912 photograph below shows the school's two teachers and their students. The new school burned down in 1917, and although the children evacuated safely, the building's contents were destroyed. The property was sold at auction, and the school was relocated to the site of the present town park. (Above, courtesy of Douglas A. Wolfe; below, courtesy of the Wilmington Historical Society, Helen Warren Collection)

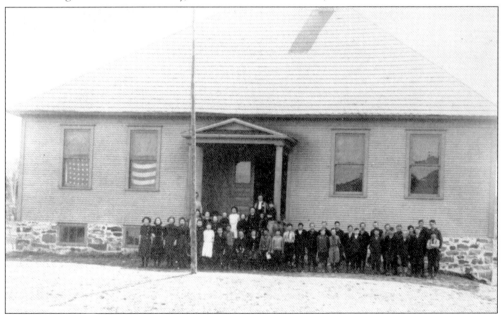

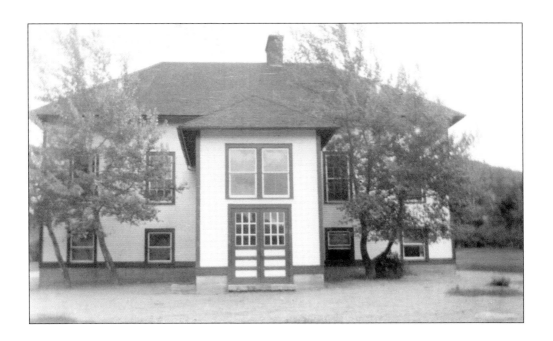

The Wilmington Village School site was relocated after the fire of 1917, and land was purchased from Albert Wilkins for $200. Above, this 1950s photograph shows the school at its new site on Springfield Road. The two-story, three-classroom building housed Wilmington schoolchildren until the district was centralized with the Lake Placid School District in 1966 and required students to be bused out of town. The old school remained vacant and was later demolished. In the c. 1908 photograph below, children at the Upper Forge School on Fox Farm Road dress in costume, apparently portraying Indians and Pilgrims. The Pelkey and Denton families are represented here. (Above, courtesy of the Wilmington Town Historian, Myron Seeley Collection; below, courtesy of the Stephenson family.)

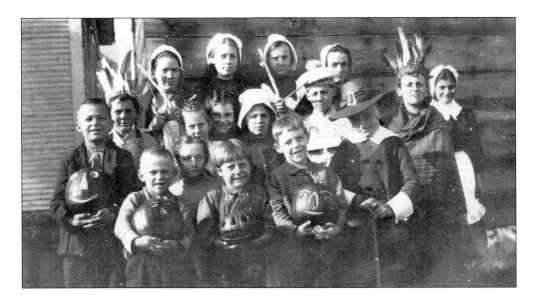

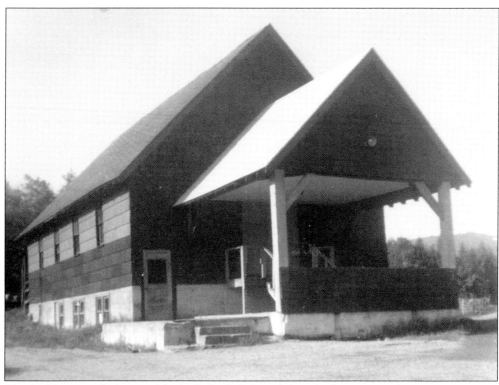

This building was the home of the Help Each Other Club in the late 1920s. The organization was associated with the Ku Klux Klan but was not racially motivated. Instead, the group practiced religious and political discrimination, as was common in northern New York at the time. Later uses for the building included the American Legion Post, town hall, library, Waldorf School, and Whiteface Range Hall. (Courtesy, Wilmington Historical Society, Ruth Boyer Collection.)

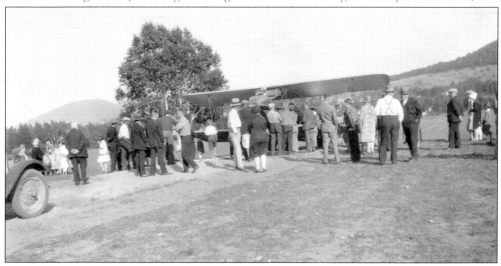

Local businessmen who foresaw aviation's future role as a way of accessing rural Wilmington constructed a modern two-runway landing field with an office along the AuSable River's west side in 1928. Early users included barnstormers, businessmen, sportsmen, and a weekly air service by Albany Air Service. (Courtesy of the Connor and Wolfe families.)

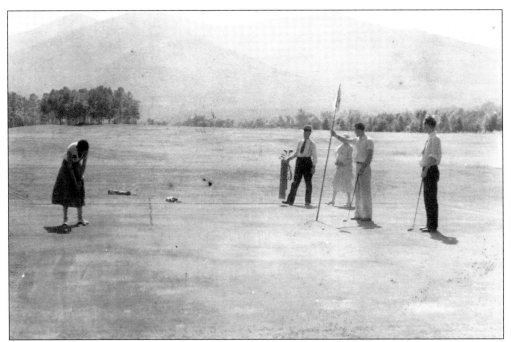

Wilmington tourism included golf amenities with the development of the Bonnie View Golf Course by James C. Wolfe in 1927. The course designer, Seymour Dunn of Lake Placid, used pastures to create a nine-hole course with a clubhouse. The resident instructor and operator was James H. Wolfe, and "Golf by Moonlight" was popular, with liberal hole pars. The course closed in 1952. (Courtesy of the Dubois and Wolfe families.)

As baseball was becoming popular, Wilmington formed a team, seen in this early-1920s photograph. With their "fast swinging" and "combination plays," they were competitive. Players are, from left to right, (first row) Jesse Kilburn, Frank Hewitt, Guy Everest, Bert Cooper, and Charles Farrell; (second row) Billy O'Reilly, Bill Smith, Claude Hathaway, Earl Taylor, and Cecil Taylor. (Courtesy of Suzanne Underwood Field.)

In the early 1800s, a small nucleus of people in Wilmington—Mr. and Mrs. Reuben Partridge and Reuben and Polly Sanford— activated a Methodist Society. They began meeting at each other's homes with prayer and Bible study. By 1833, Reuben Sanford initiated actual construction of the Wilmington Methodist Episcopal Church, which was completed in 1834. This image was taken in the late 1800s. (Courtesy of the Wilmington Town Historian.)

Built in 1834, the Congregational church is seen here around 1900 with Rev. John Urban standing out front. The adjacent horse sheds were added in 1897 for $360. The congregation dissolved in 1907. The Wilmington Nazarene Church organized in 1905 under the leadership of Daniel Haselton. The official church was established in 1921 with 14 members, incorporated in 1932, and assumed ownership of the building. (Courtesy of Beatrice Lawrence.)

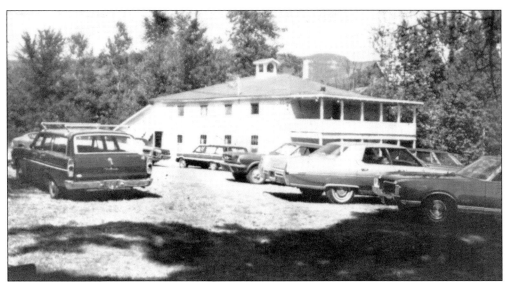

Shown here is the dining hall of the Wilmington Interdenominational Holiness Camp meeting site on Hardy Road. The camp was started in 1905 on land given by Dean Hardy, with tents and buildings being erected for worship and accommodations. Camp meetings were popular for religious and spiritual renewal. Continuing the tradition, services are still held on these grounds. (Courtesy of Merri C. Peck.)

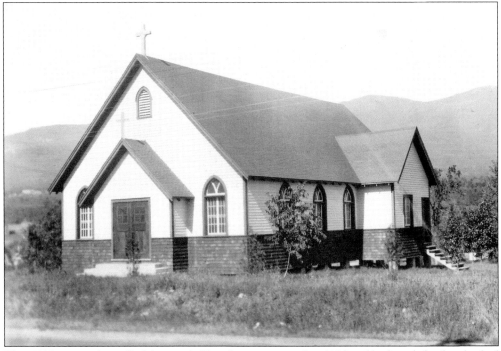

This 1930s image shows St. Margaret's Church, incorporated in 1926 and built with funding backed by John J. O'Leary and George Smith. The church was named for the patron saint of Margaret Courtney Smith, George's mother. When a strong autumn wind shifted the church off its foundation, Mass had to be temporarily held at John J. O'Leary's residence. (Photograph by the Wilmington Chamber of Commerce; courtesy of Mary Shea Miskovsky, Smith Family Collection.)

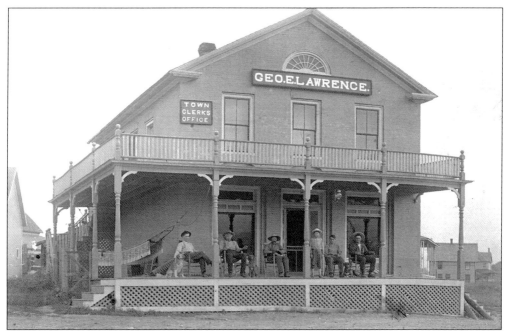

The George Lawrence Store, a popular gathering place at the corner of Upper Jay and Jay Roads, is seen here about 1900. The second floor housed the town clerk's office. Likely built by Reuben Sanford, it was owned by the Westons in the 1870s. It burned in the early 1900s, was rebuilt as Cooper's Store, and was later occupied by Hazel and Bill's Restaurant. (Courtesy of the Urban family.)

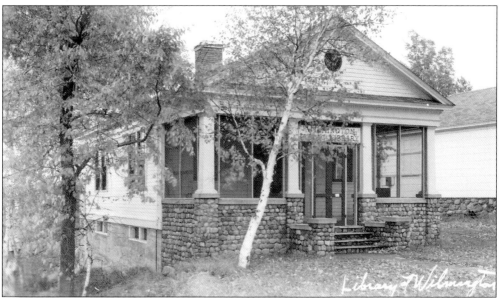

Ellison Minor Cooper, a successful Philadelphia businessman, built the public library in his hometown of Wilmington as a legacy. He left a substantial bequest and over 5,000 books to help support it. The E.M. Cooper Memorial Library Association was formed on August 20, 1918, and the library was temporarily housed in the lower level of the Methodist church until the new building was completed in 1934. (Courtesy of Charles Haselton.)

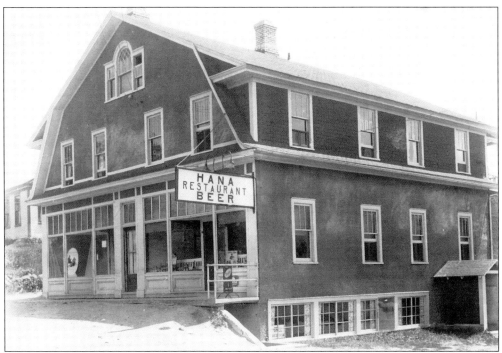

Once owned by George "Grubby" Marshall, the building pictured above in the mid-1930s housed a restaurant on the first floor and apartments above. At one time, there was also an electrical and contracting business, Marshall & Brindley, on the basement level. After the Whiteface Memorial Highway and new stone bridge were constructed in the 1930s, the building had to adjust to the raised roadbed. In the same structure, as seen in the 1958 photograph below, one had to descend stairs to enter the Whiteface Market. The building has also housed the AuSable River Sport Shop and is currently the location of the Lake Everest Diner. (Both, courtesy of the Essex County Clerk.)

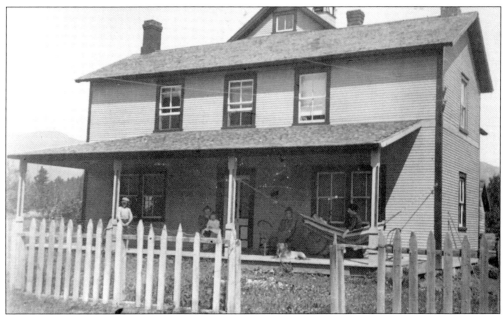

As seen in this late-1800s photograph of the Haselton family, the Haselton/Warren house is located in the old Markhamville (now Haselton) area of Wilmington. It was constructed around 1840 by Nathan B. Markham. His son Henry Harrison Markham, who grew up on the farm and was educated in the one-room Markhamville schoolhouse, became governor of California, serving from 1891 to 1894. (Courtesy of the Wilmington Town Historian, Helen Warren Collection.)

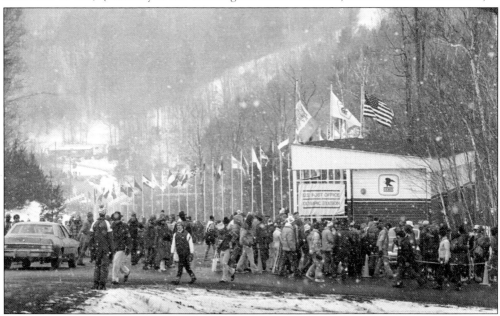

The US Postal Service set up a temporary post office for the 1980 Winter Olympics' alpine venue at the entrance to the Whiteface Mountain Ski Center. This office provided philatelic, commemorative, and international sales and service to the many athletes and spectators. A First Day Cover of the new Olympic stamps, along with special pictorial cancellations, was available. (Courtesy of Merri C. Peck.)

Eight

NOTABLE PEOPLE

Asher Winch was a well-known Adirondack guide, hunter, and fisherman. He is seen here in the 1950s at his Mountain View Farm on Springfield Road with his firearms and fishing gear. He was a good storyteller, often spinning tales and entertaining his visitors, and he catered to guests here at his farmhouse and at the adjoining cottages. (Courtesy of Guy Stephenson Jr.)

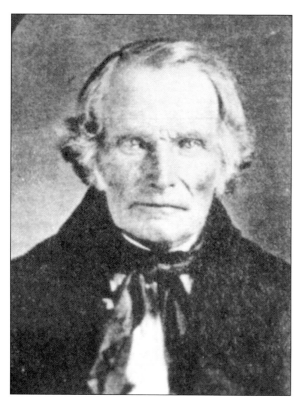

Reuben Sanford and his wife, Polly, are seen in these c. 1850 tintype photographs. The couple moved to the area from Connecticut in 1803, and Reuben went on to build a forge, a blacksmith shop, and a sawmill. He established the Sanford Iron Works, erected a potash factory, and was the first innkeeper. During the War of 1812, he was commissioned as a major, leading four companies of area militia at the Battle of Plattsburgh. When he kept the British from crossing a Plattsburgh bridge, he became a war hero. He was elected to the New York State Assembly from 1814 to 1817 and to the New York State Senate in 1828. He was also the first Wilmington postmaster. Soon after the Methodist church was completed, he erected the first store. Additionally, he served as town supervisor for two terms. (Both, courtesy of the Whiteface Community United Methodist Church.)

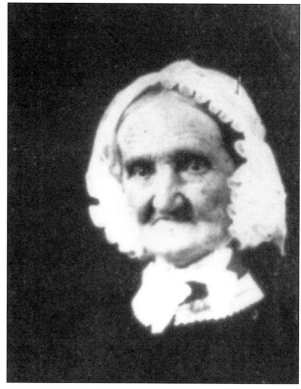

Ralza C. Lawrence was married to Mary Conoboy. He traveled to California for the Gold Rush and had a ranch there where he earned a good sum of money before returning to Wilmington. He served as town supervisor from 1870 to 1872, 1879 to 1880, and 1887 to 1888. He owned several parcels of land and was known as a generous man. (Courtesy of the Allan Lawrence collection.)

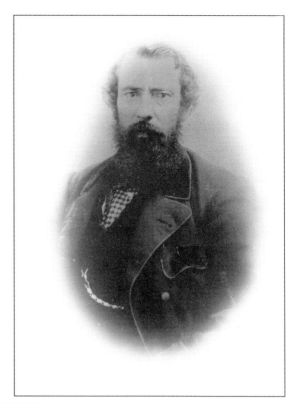

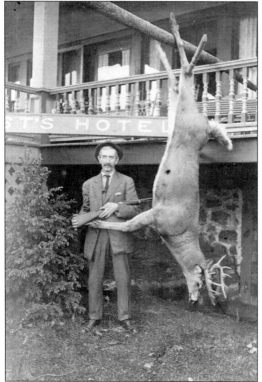

Frank Everest married Bessie Olney in 1890 and began an extensive career with roles including store owner, town clerk, supervisor, postmaster, and events chairman, in addition to his hotel and land ownership. His outgoing personality and unique political savvy won many important friends and projects, including electric service, telephones, and the Whiteface motor road for Wilmington. (Courtesy of the Wilmington Town Historian, James Olney Collection.)

Electa Hayes was born in July 1855, the daughter of Aaron and Oxie Preston Hayes. A lifelong resident of Wilmington, she taught school and Sunday school and was a laundress, manager, farmer, and dressmaker. She served on the library's first board of trustees and was its secretary for many years. She was influential in moving Wilmington forward. (Courtesy of the Wilmington Town Historian, Hayes Collection.)

James C. Wolfe, born in 1882, was elected to four successive terms as town supervisor for Wilmington. He was also Essex County sheriff, Sunday school superintendent, Methodist Church board of trustees member, library board of trustees president, and chamber of commerce president. In addition, he was a teacher, farmer, entertainer, and musician, and he owned and operated a summer home for tourists. (Courtesy of Douglas A. Wolfe)

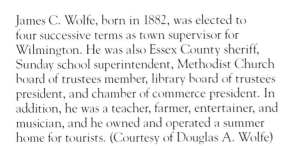

George "Adirondack" Smith, seen here in 1915, was born in nearby AuSable Forks in 1867. He moved to Springfield, Massachusetts, and became successful in the manufacture of metal automobile bodies, supplying the coachwork for Hupmobile and Checker Cab in the 1920s. While maintaining his Wilmington Gun Club Cottage and local connection, he became instrumental in the development of the Whiteface motor road. (Courtesy of Mary Shea Miskovsky, Smith Family Collection.)

Ellison Minor Cooper, grandson of Minor Cooper, was born in Wilmington in 1854. He became a prominent and successful businessman in Philadelphia, Pennsylvania, and left a legacy in the form of a substantial bequest for a public library to be built in his boyhood hometown. E.M. Cooper died in Philadelphia in September 1920. (Courtesy of the Wilmington Town Historian.)

Willard and Laura Lawrence Haselton were lifelong residents of Wilmington. When Willard began working for Haselton Lumber Company in 1912, he earned $1.50 for a 10-hour day. He became a partner in 1929, then president in 1941. Willard retired in 1963 from the family business, which still exists today. Laura became well known for her church and community work with youth and missions. (Courtesy of the Haselton Lumber Company.)

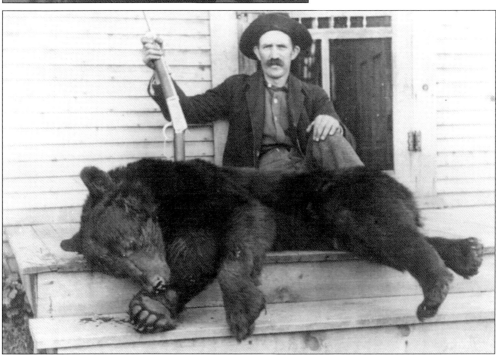

This early-1900s real-photo postcard of Asa Lawrence provides advertising for this well-known Adirondack guide, nimrod, and fisherman, who had the reputation of being a champion bear hunter. Asa was a fire observer on Whiteface Mountain and watchman, or "gate guard," at the tollgate during the Whiteface Highway construction. (Courtesy of Gerald Bruce.)

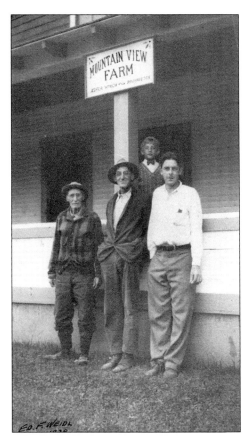

Seen in the 1929 image right are, from left to right, Cassius Winch, Asher Winch, unidentified, and Era Winch, standing in front of their Mountain View Farm, known as a "hunter's paradise." The farm served as a base for hunting and fishing trips into the woods, and guiding skills were passed from generation to generation. Pictured at the Winches' Copperas Pond Camp in the early-1900s photograph below are an unidentified sportsman (left), Cassius Winch (center), and Asher Winch. Hunting and fishing enthusiasts sought out guides with the best services and knowledge of the local area. Cassius and Asher built log cabins and had boats at Copperas, Winch, and Owens Ponds for use by their guests. The guide camps served the needs of both hunter and fisherman. (Both, courtesy of Carol Latone, Winch Collection.)

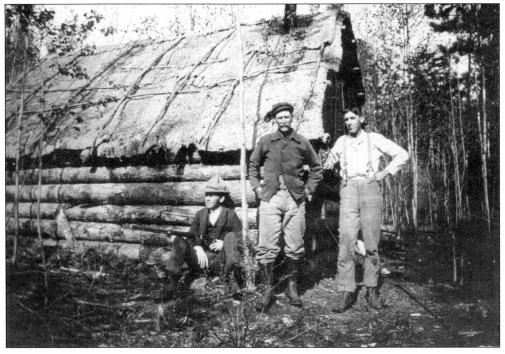

Ida Gardner Greason Underwood and her husband, Louis Edward Underwood, are seen on their wedding day at Bluebird Camp in Wilmington in August 1919. Ida Gardner, an opera contralto, also worked with Thomas Edison to develop and promote phonographs and records. She and Louis, an engineer, met at the Lake Placid Club; she came to perform, and he was attending a General Electric Company conference. (Courtesy of Suzanne Underwood Field.)

Clara Merrill is seen here with her daughter Mildred about 1915. Clara's husband, Wilbur Merrill, was an engineer and inventor for General Electric Company in Schenectady, New York. Mildred, Clara and Wilbur's only child, was unexpectedly killed in an automobile accident in 1917. In 1920, Clara, along with her sister Martha Brown, established the Owaissa Club for young people in Wilmington in Mildred's memory. (Courtesy of Suzanne Underwood Field.)

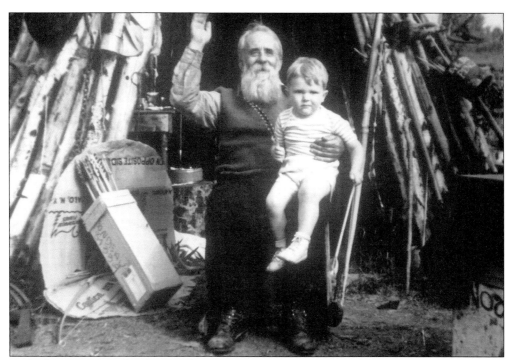

In the late 1920s, Noah John Rondeau left civilization for a wilderness life at remote Cold River in the western Adirondacks. He kept extensive coded journals of his experiences. In 1947, he appeared at the National Sportsmen's Show in New York City, becoming an instant national phenomenon. In 1950, a blowdown leveled the forest, and the Conservation Department compelled Noah to leave his home. He moved from place to place, working occasional side jobs, until, in 1963, he was given Singing Pines, a converted chicken coop on Springfield Road in Wilmington. There, he gardened, chopped wood, fed birds, and tended fruit trees. Above, around 1960, famed "Adirondack Hermit" Noah John Rondeau engages in a photo opportunity at his Whiteface Highway teepee. At right, Noah is a substitute Santa at Santa's Workshop in the 1950s. (Both, courtesy of William J. "Jay" O'Hern.)

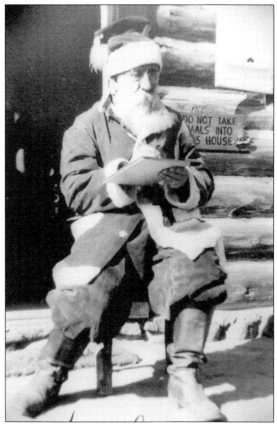

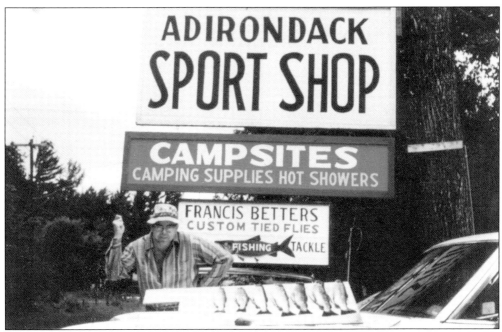

A fly-fishing legend on the West Branch of the AuSable River and later a member of the Fly Fishing Hall of Fame, Francis Betters poses with a catch of trout in front of his Adirondack Sport Shop in the above 1960s photograph. The shop, built in 1963, featured fishing, camping, and Adirondack craft items. Fran's shop became a famous destination for anglers for over 40 years. In addition to being an expert fisherman, he was a newspaper columnist and author. Below, Fran can be seen tying one of the 5,000 AuSable Wulff flies he tied each year. He also developed the fly patterns of the "Haystack" and the "Usual" and built his own custom rods. Fran, a native son of Wilmington, turned his passion for fishing the AuSable River into a lifelong occupation. (Both, courtesy of Peggy Betters.)

Olympians Ross Zucco (left) and Jeanne Ashworth (center) meet Sen. John F. Kennedy at the 1960 Squaw Valley Winter Olympics. A speed skater, Jeanne won the bronze medal in the 500-meter event and finished eighth in both the 1,000- and 3,000-meter events. She also competed in the 1964 and 1968 Olympics, and she served as Wilmington's town supervisor from 2000 to 2007. (Courtesy of Jeanne Ashworth.)

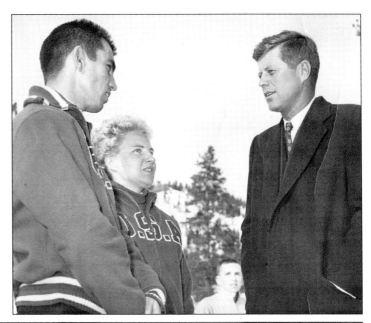

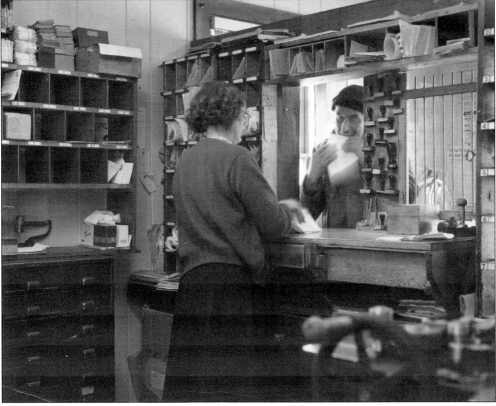

Edna Mulvey, postmaster from 1962 to 1971, is seen in this behind-the-scenes photograph of the Wilmington Post Office serving customer John J. O'Leary. O'Leary moved to Wilmington and built what was known as the O'Leary Castle on Reservoir Road. He served as a Town of Wilmington attorney and as caretaker for the reservoir. (Courtesy of the Wilmington Town Historian.)

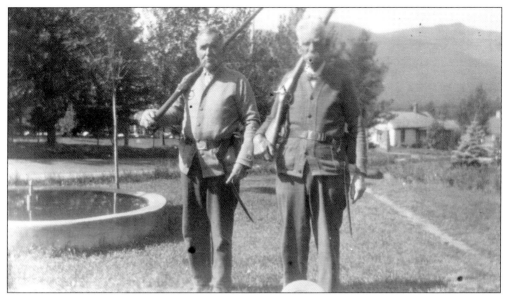

Oscar Maynard and Minor Cooper were Wilmington's last surviving Civil War veterans. Maynard fought with the New York 93rd Volunteer Infantry in nine major engagements and was wounded in the Battle of the Wilderness. Cooper served with the New York 96th Volunteer Infantry and was a prisoner of war in the Andersonville Prison, surviving with lasting health problems. They both died in the 1930s. (Courtesy of the Wilmington Town Historian.)

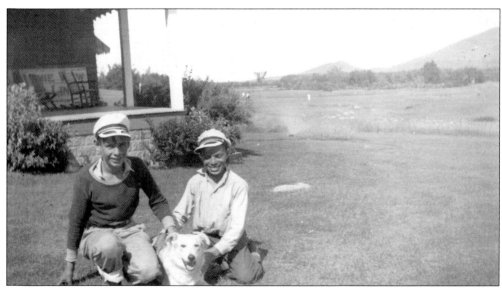

Young caddies Dietrich Lee Hinds (left) and Ernest Boudreau (right) earned pocket money at Bonnie View Golf Course during the summer of 1939. Both young men served during World War II, but while Lee returned a decorated Air Army Force veteran, receiving the Distinguished Flying Cross, Ernest, sadly, was killed in Italy in 1944 while serving with Company L, 338 Infantry American, Fifth Army. (Courtesy of Douglas A. Wolfe.)

Edwin J. Olney, seen at right, was born in Gouverneur in 1841. After living in various Midwest states, he returned to enlist in the 60th New York Volunteers/Veterans St. Lawrence Regiment and in four years saw action from Bull Run to Atlanta. He married Helen Bliss in 1867 and established the Hotel Olney with Riverside Cottage as a popular visitor's destination. His community services included auditor, councilman, justice of the peace, Baptist lay minister, and Grand Army of the Republic and Masonic Lodge member. His children included Oscar, William, Frank, and Bessie. Oscar Olney, seen below with his wife, Alice, partnered with his father at the Hotel Olney. He and Alice developed a contracting business and built houses, bungalows, and rustic furniture, their specialty. He was a councilman and water commissioner, serving and aiding Wilmington's expansion. (Both, courtesy of Suzanne Underwood Field.)

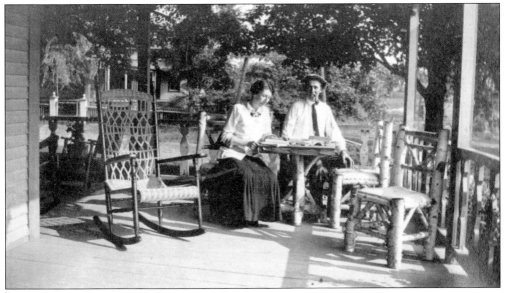

BIBLIOGRAPHY

Allen, John, and Ekkehart Ulmrich with editorial staff. "The Man *Who Started It All.*" *Skiing Heritage, Journal of the International Skiing History Association.* Fall 1996: 9–19.

Essex County Historical Society, E. Gilbert Barker. *An Essex County Historic Resources Survey of the Town of Wilmington, New York,* 1980.

Jaques, Adeline. *Echoes From Whiteface Mountain: A Brief History of Wilmington, New York.* Wilmington, NY: self-published, 1980.

news.nnyln.net

O'Hern, William J. *Noah John Rondeau's Adirondack Wilderness Days.* Cleveland, NY: Forager Press, 2009.

Roosevelt, Franklin D. *The Public Papers and Addresses of Franklin D. Roosevelt, Volume 4: The Court Disapproves, 1935.* New York: Random House, 1938.

Stoddard, Seneca Ray. *Old Times in the Adirondacks.* Burlington, VT: George Little Press, 1971.

"Wilmington." *New Topographical Atlas of Essex County, New York.* Philadelphia: O.W. Gray & Son, 1876.

Winch, Oliver W. *Wilmington of the Adirondacks: A Brief History.* Wilmington, NY: self-published, 1974.

www.haseltonlumber.com

ABOUT THE WILMINGTON HISTORICAL SOCIETY

The mission of the Wilmington Historical Society is to collect, preserve, display, and interpret the documents, photographs, and artifacts that tell the unique story of how the people of this remote, mountainous small town with big ideas have adapted and survived in the harsh yet beautiful environment of the Adirondacks. The society is a 501(c)(3) nonprofit organization, having received a New York State provisional charter in 2003 and a New York State absolute charter in 2011. The organization holds regular monthly meetings, displays collections, provides research hours, and offers programs to the public. The Wilmington Historical Society has also produced a cemetery project in conjunction with RootsWeb (www.rootsweb.ancestry.com), which appears on the website (www.wilmingtonhistoricalsociety.org). The organization is also now on Facebook at www.facebook.com/WilmingtonHistoricalSociety.

DISCOVER THOUSANDS OF LOCAL HISTORY BOOKS
FEATURING MILLIONS OF VINTAGE IMAGES

Arcadia Publishing, the leading local history publisher in the United States, is committed to making history accessible and meaningful through publishing books that celebrate and preserve the heritage of America's people and places.

Find more books like this at
www.arcadiapublishing.com

Search for your hometown history, your old stomping grounds, and even your favorite sports team.

Consistent with our mission to preserve history on a local level, this book was printed in South Carolina on American-made paper and manufactured entirely in the United States. Products carrying the accredited Forest Stewardship Council (FSC) label are printed on 100 percent FSC-certified paper.

MADE IN THE